Color My Feelings

by Alexander Chrenka

© 2016 Alexander Chrenka. All rights reserved.
ISBN 978-1-329-82006-7

Foreword

This book is a series of original art pieces covering various emotions and feelings of mine. Artwork has always been my expressive and liberating tool to help cope with the stresses of everyday life, and it is my wish that you as the purchaser can feel the same way through my work. This book can serve as either a collection of my work if you are an avid fan, or you may break out your favorite medium and add to it. Reflect on my reflections and use them as a means of relieving yourself from whatever is bothering you at this current time.
Thank you for your patronage and continued support.

~Alexander

An Age Old Struggle

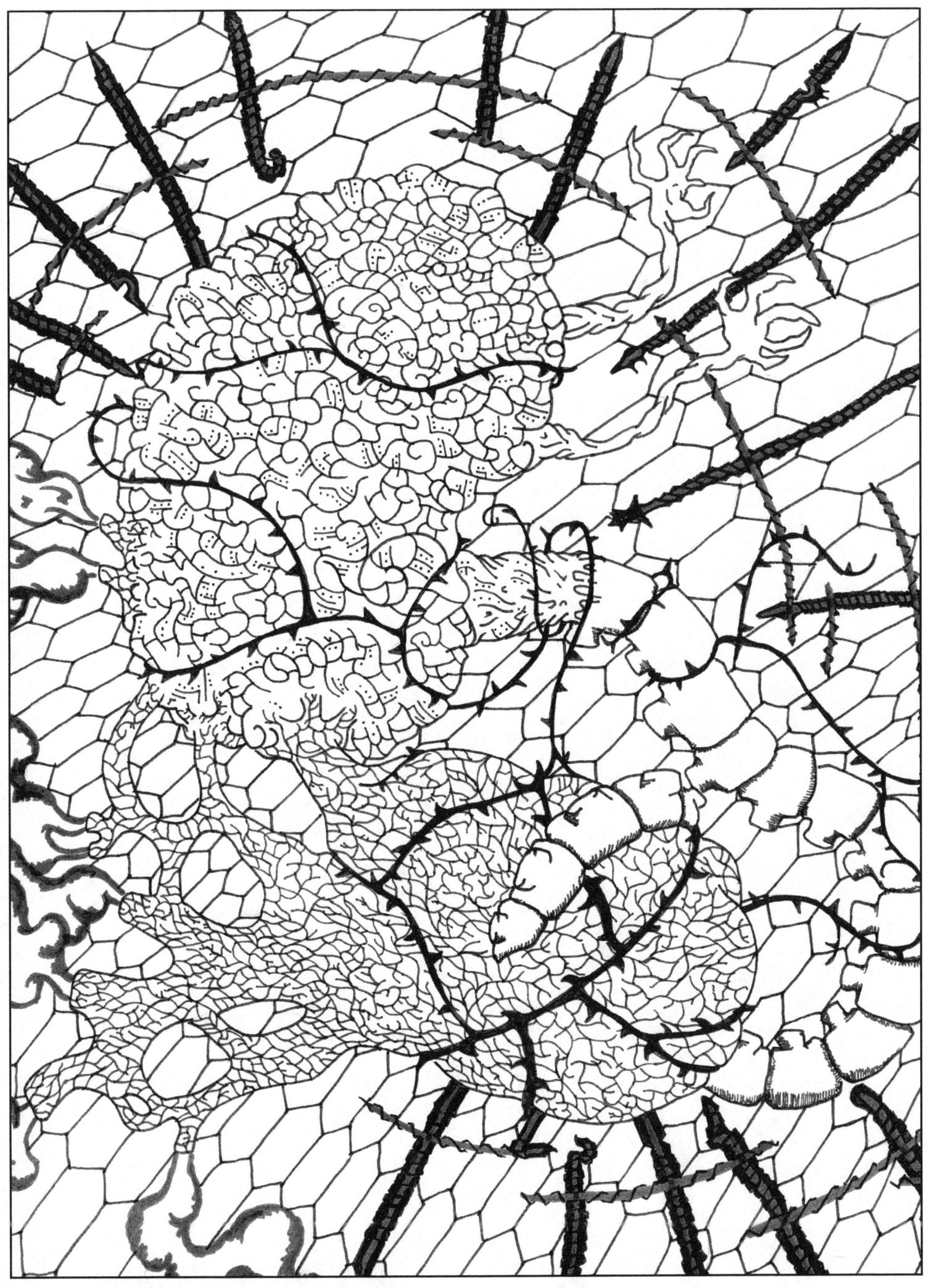

Transcendence

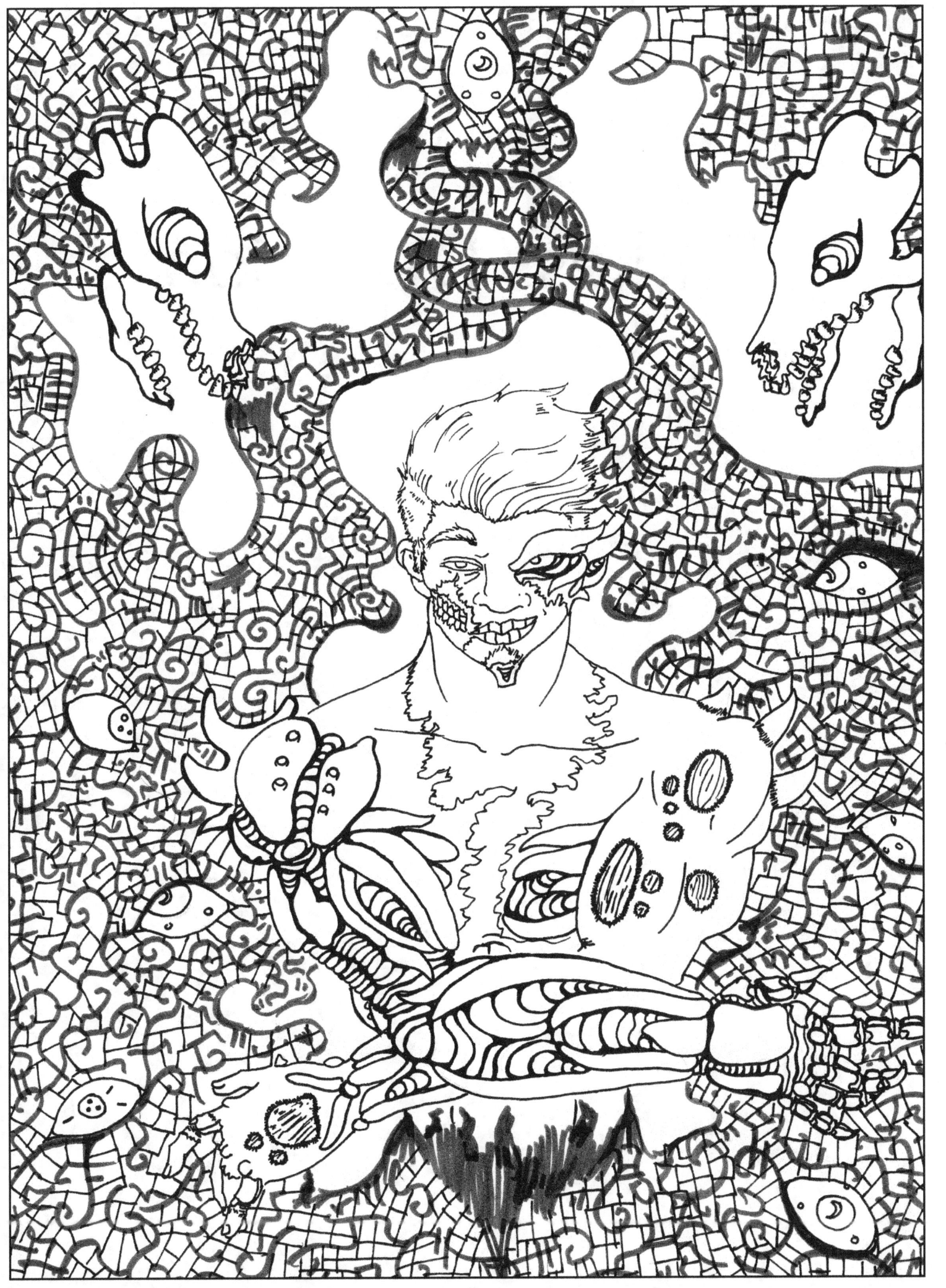

Endless Devotion

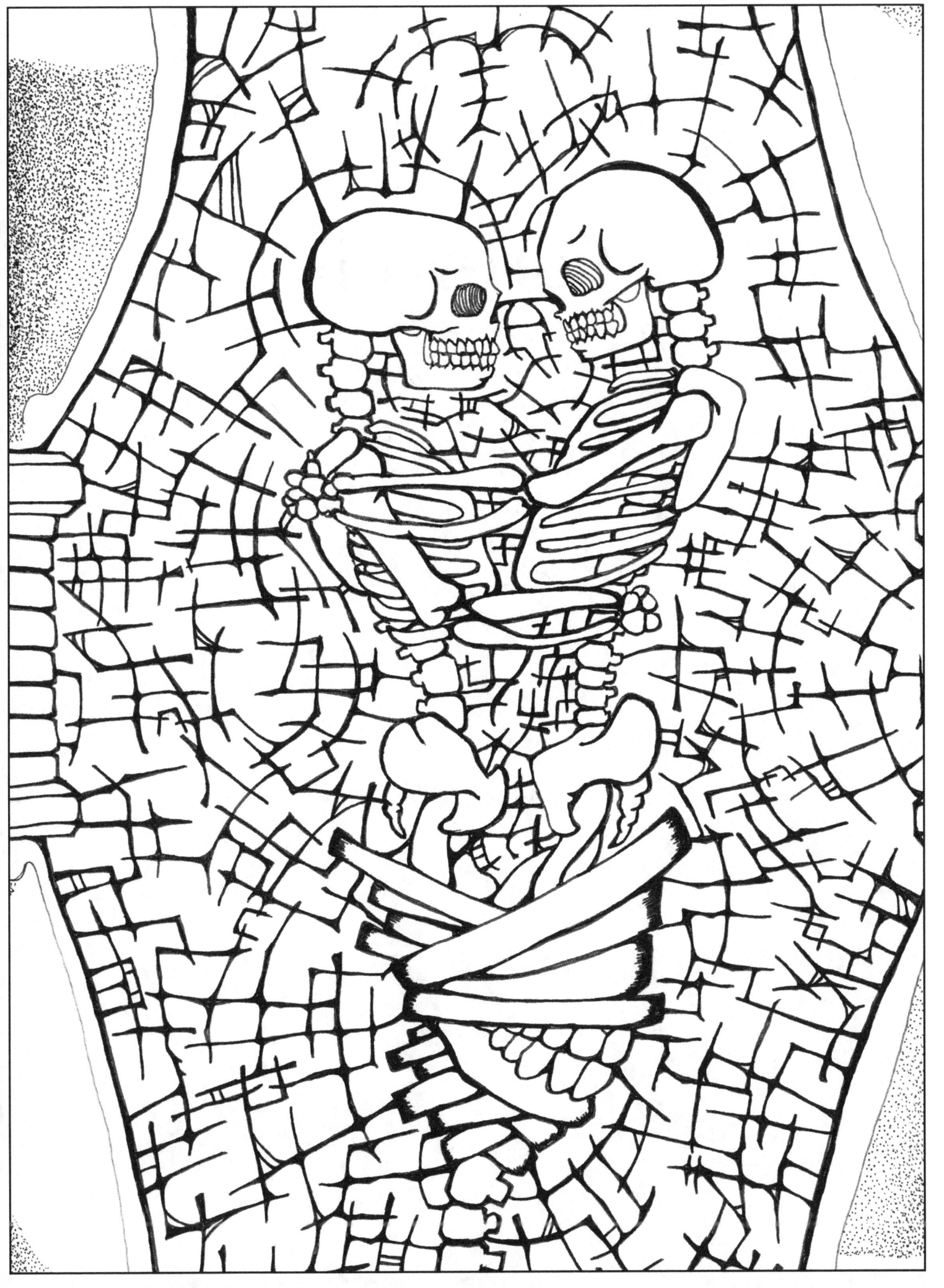

Farewell

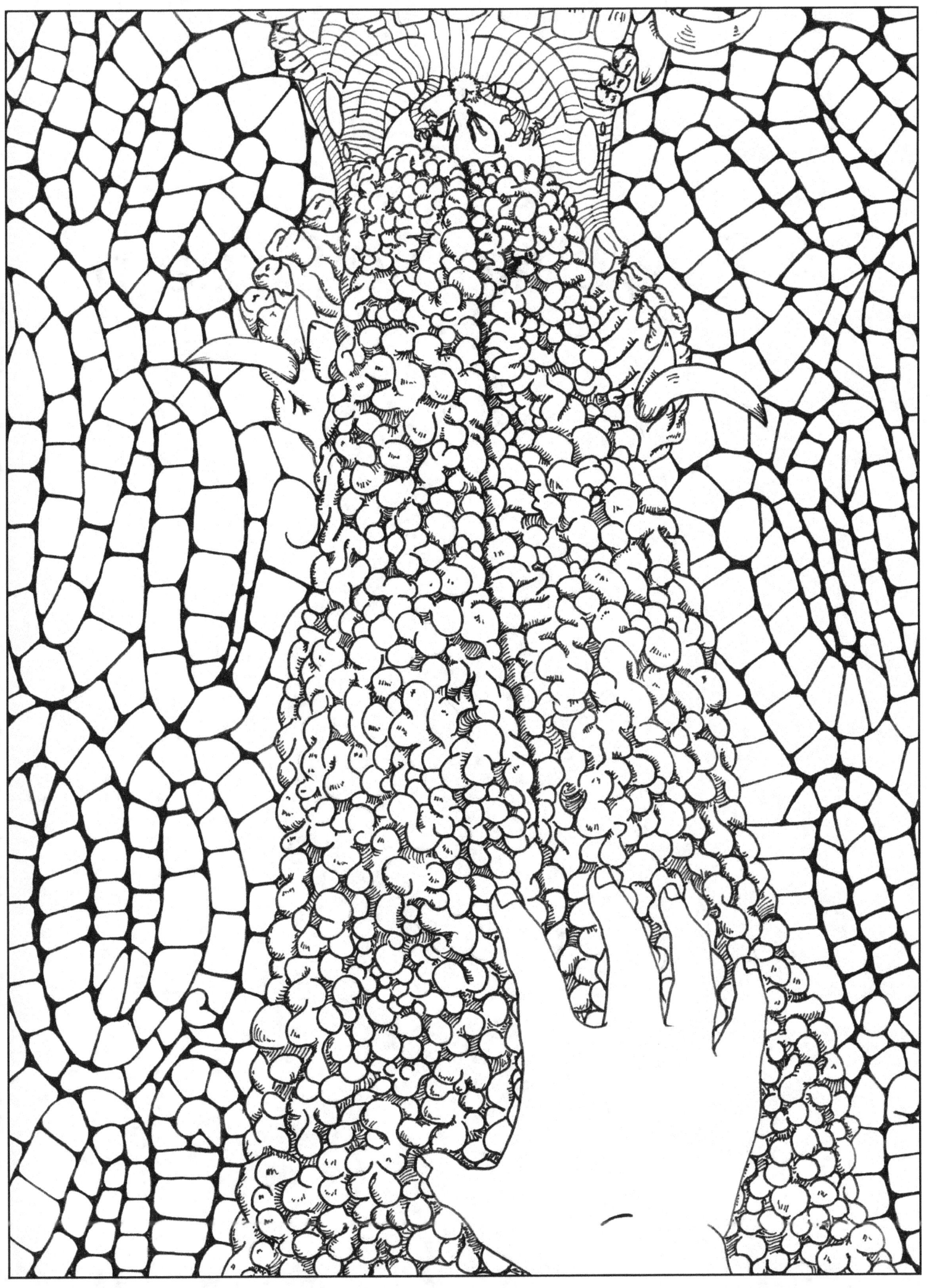

A Polychrome Dream

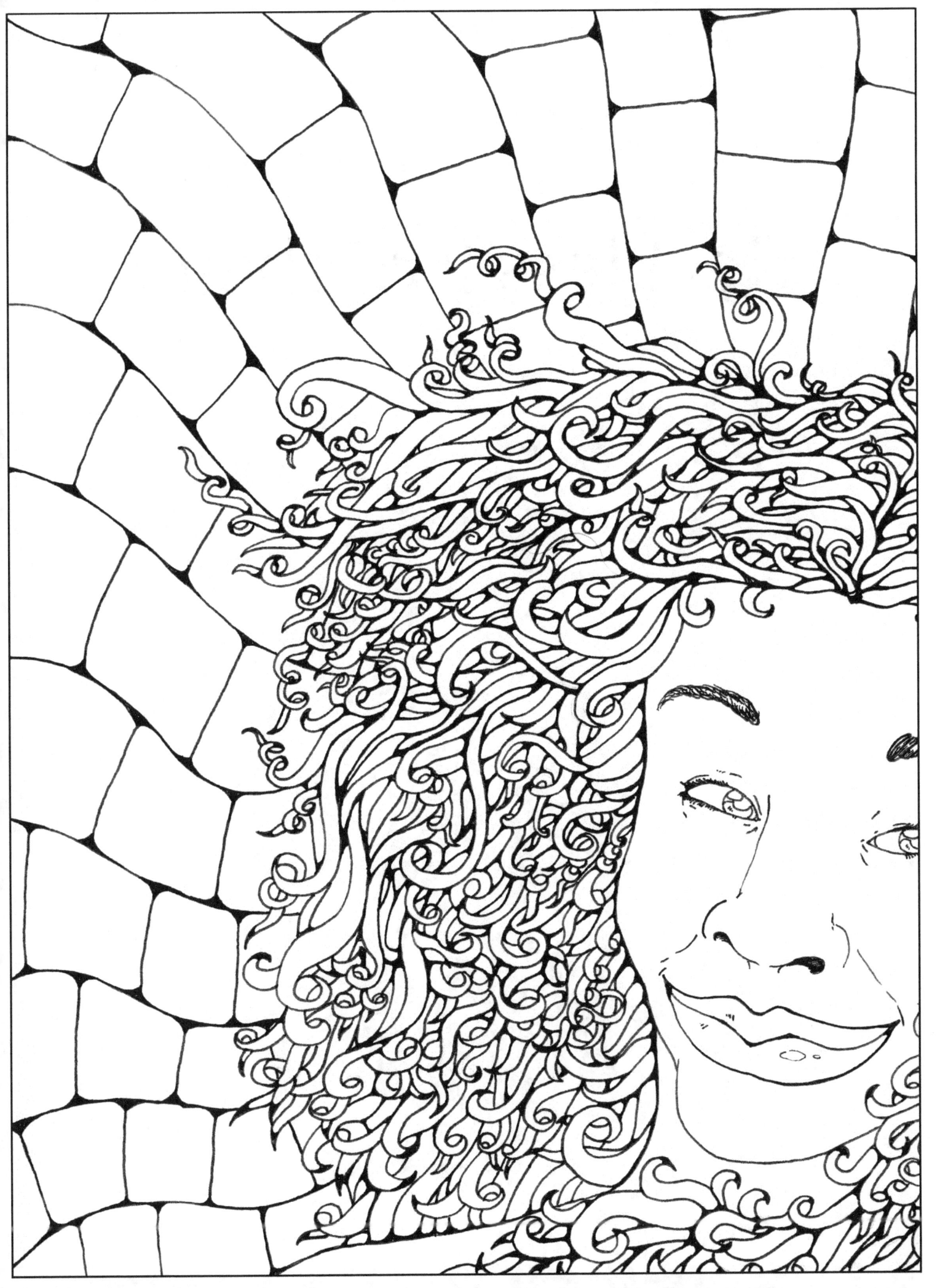

Reckless Irritability

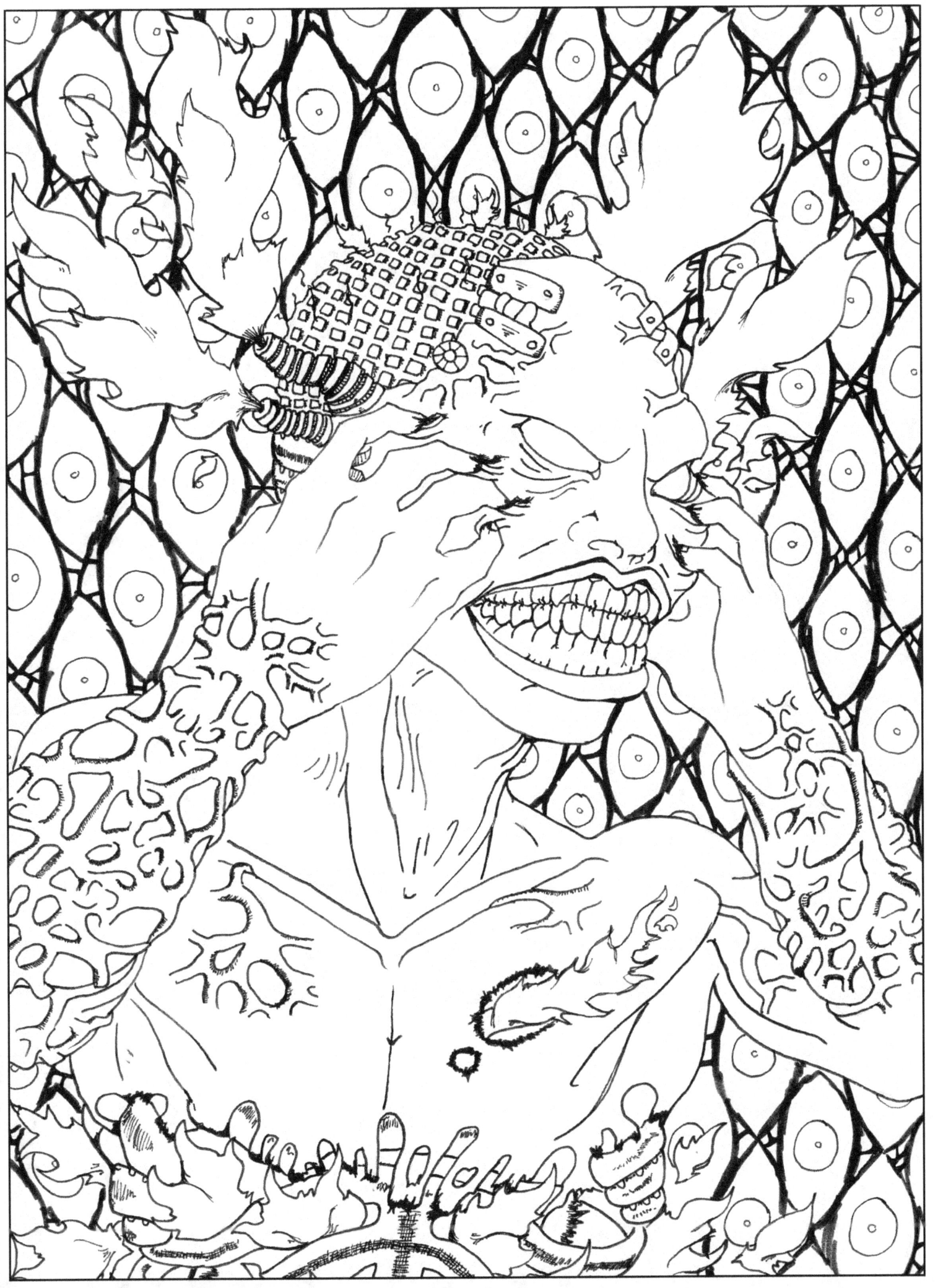

Isolation

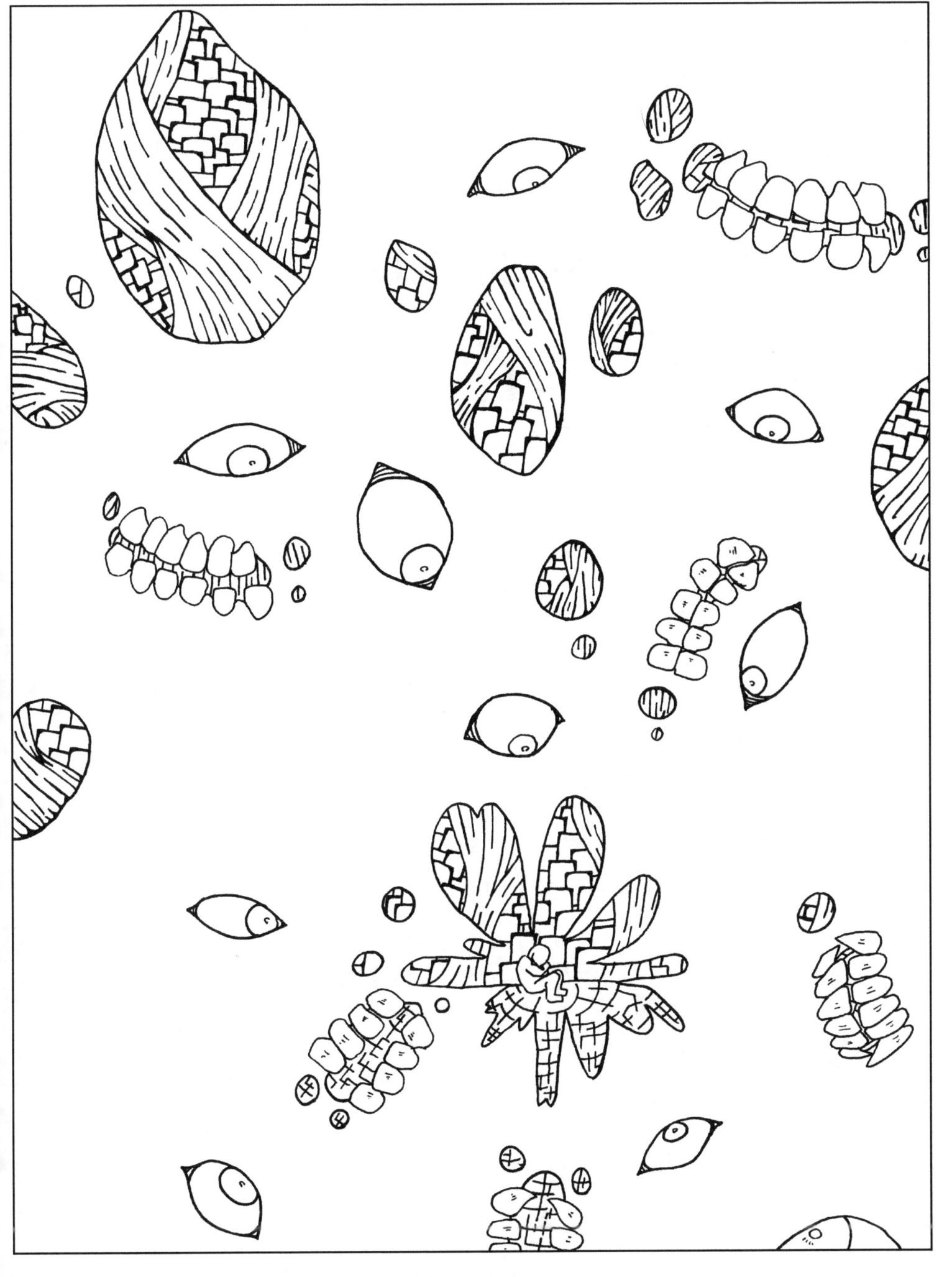

Autism

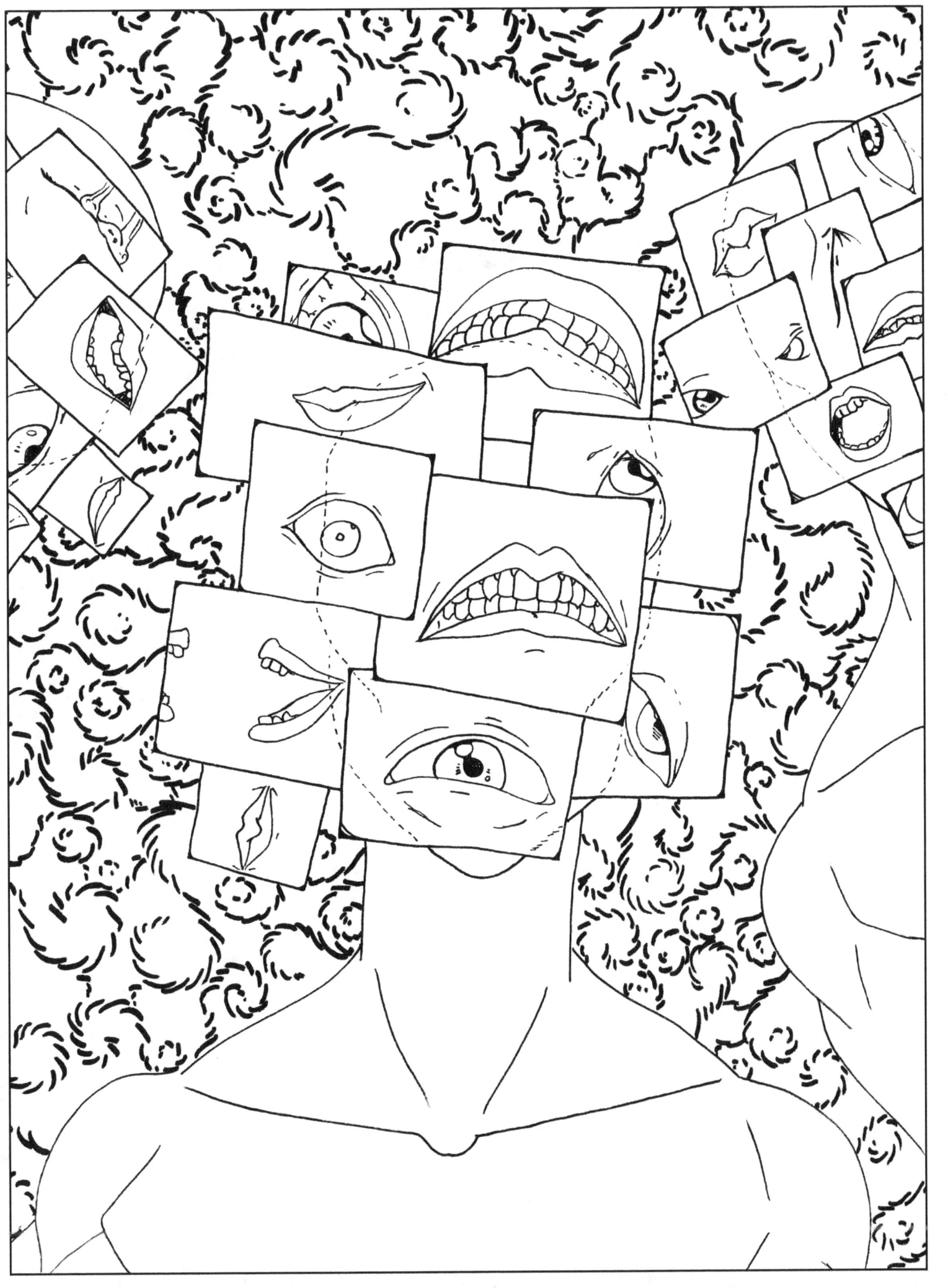

Pet

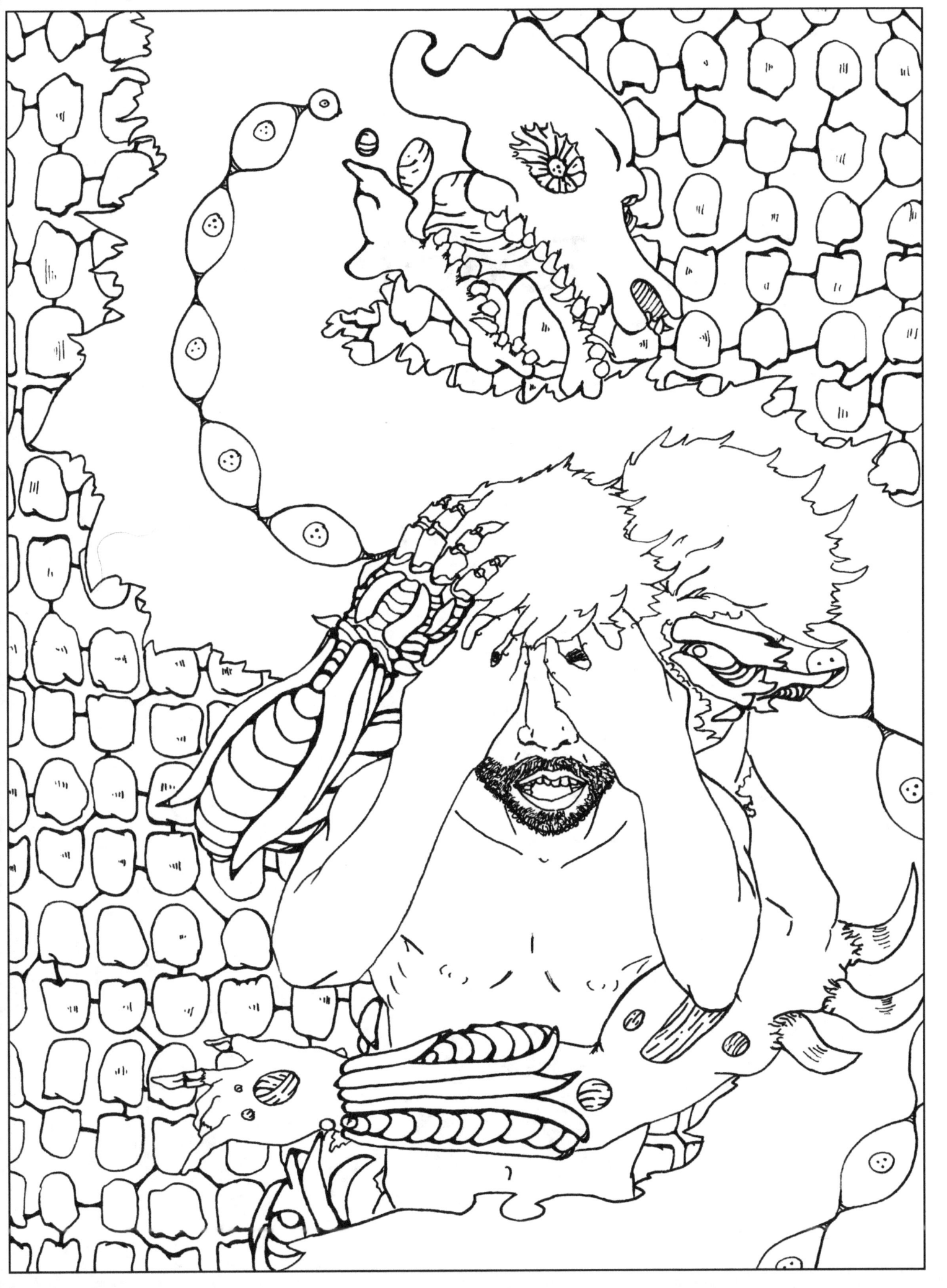

Toxicity

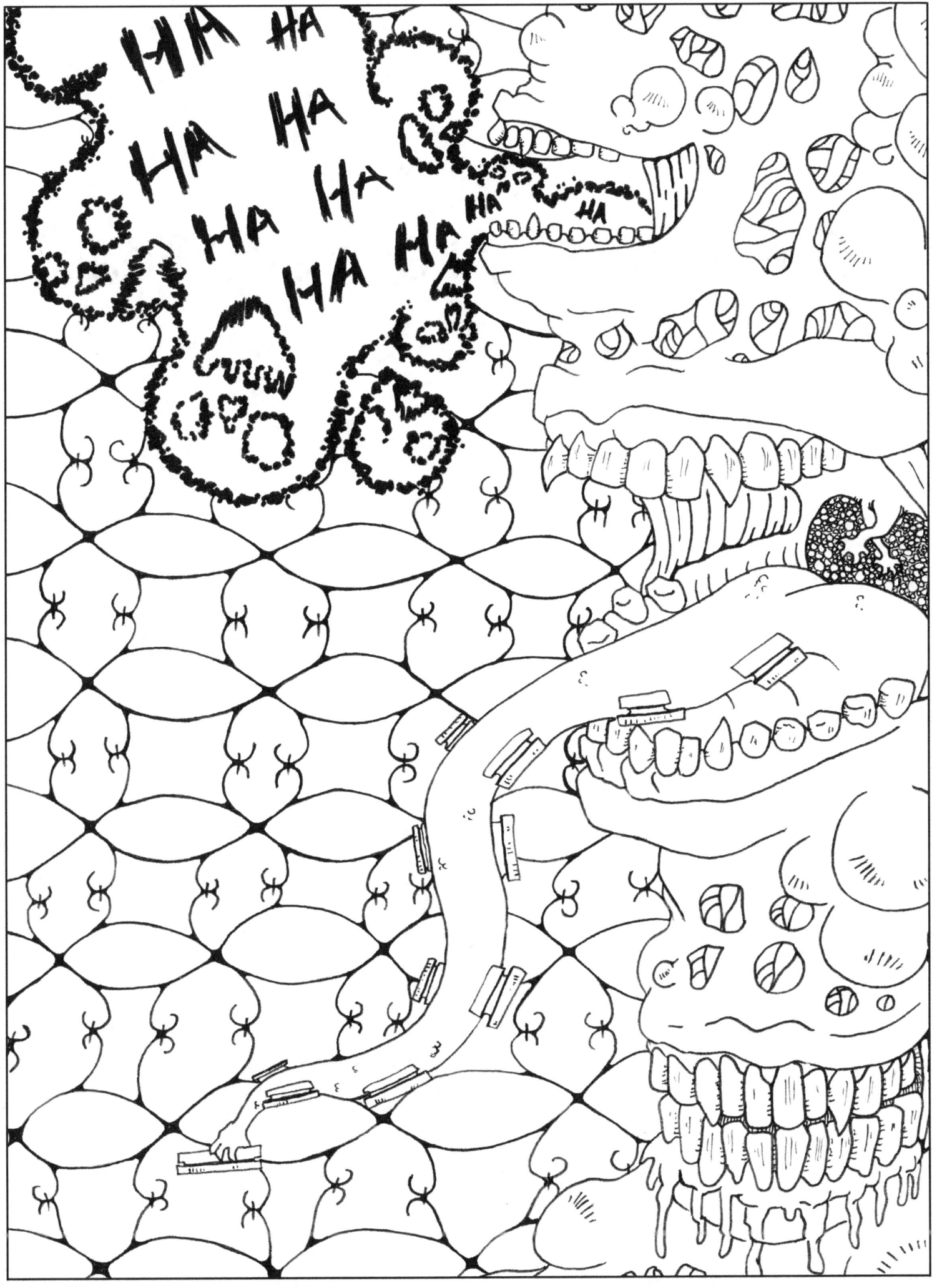

There Is Only Love and Fear

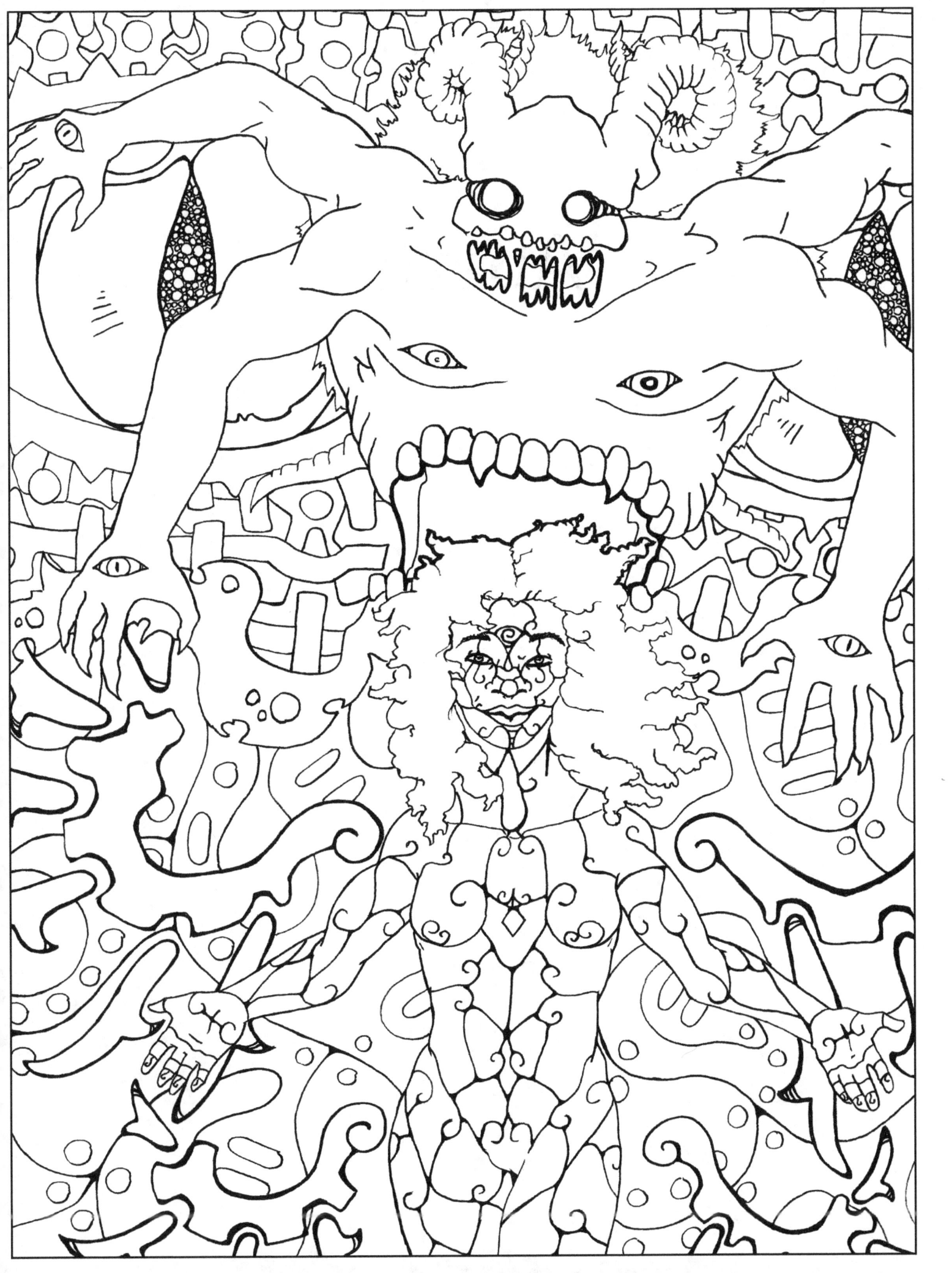

Apathy

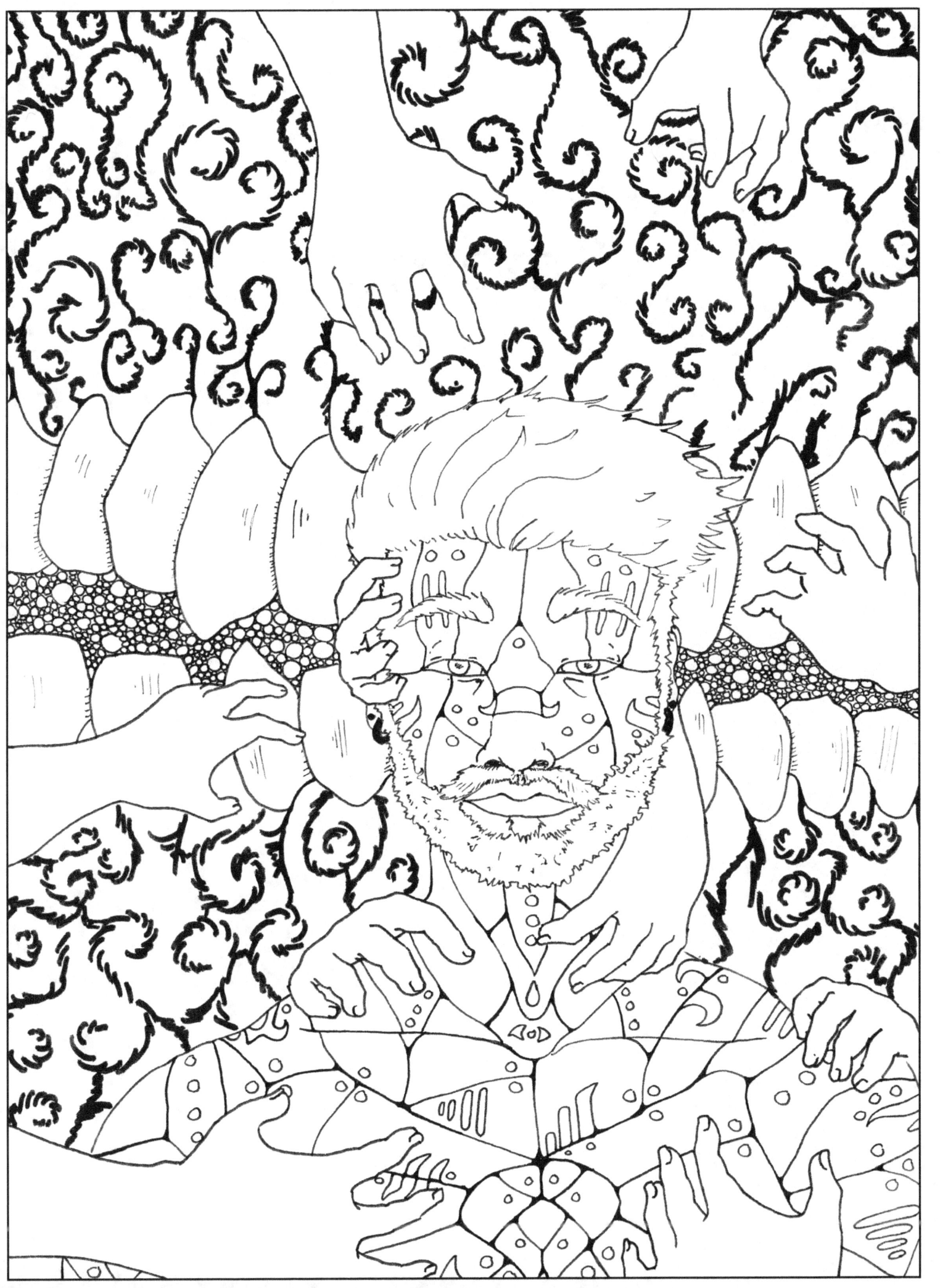

Smother

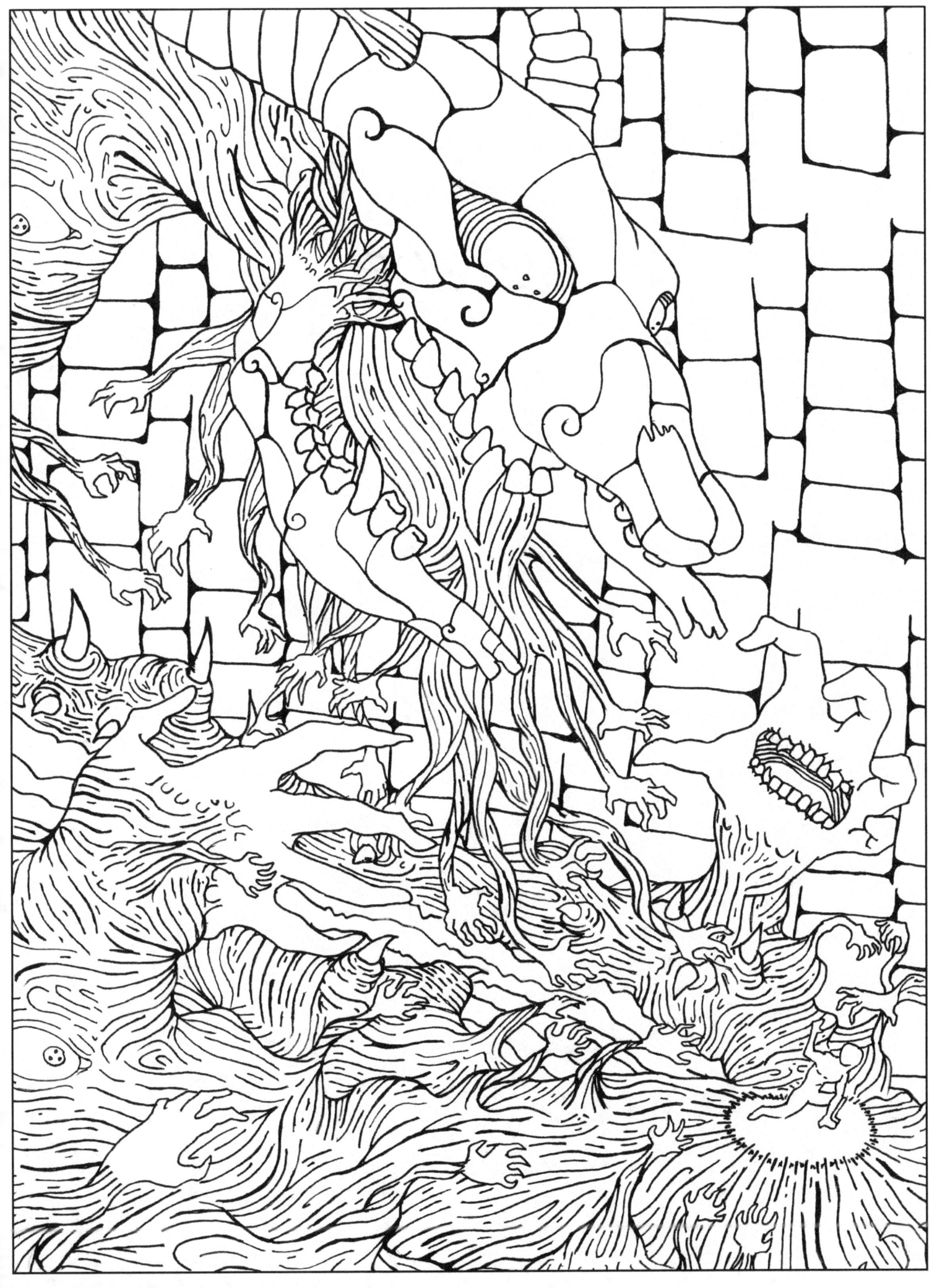

Solace

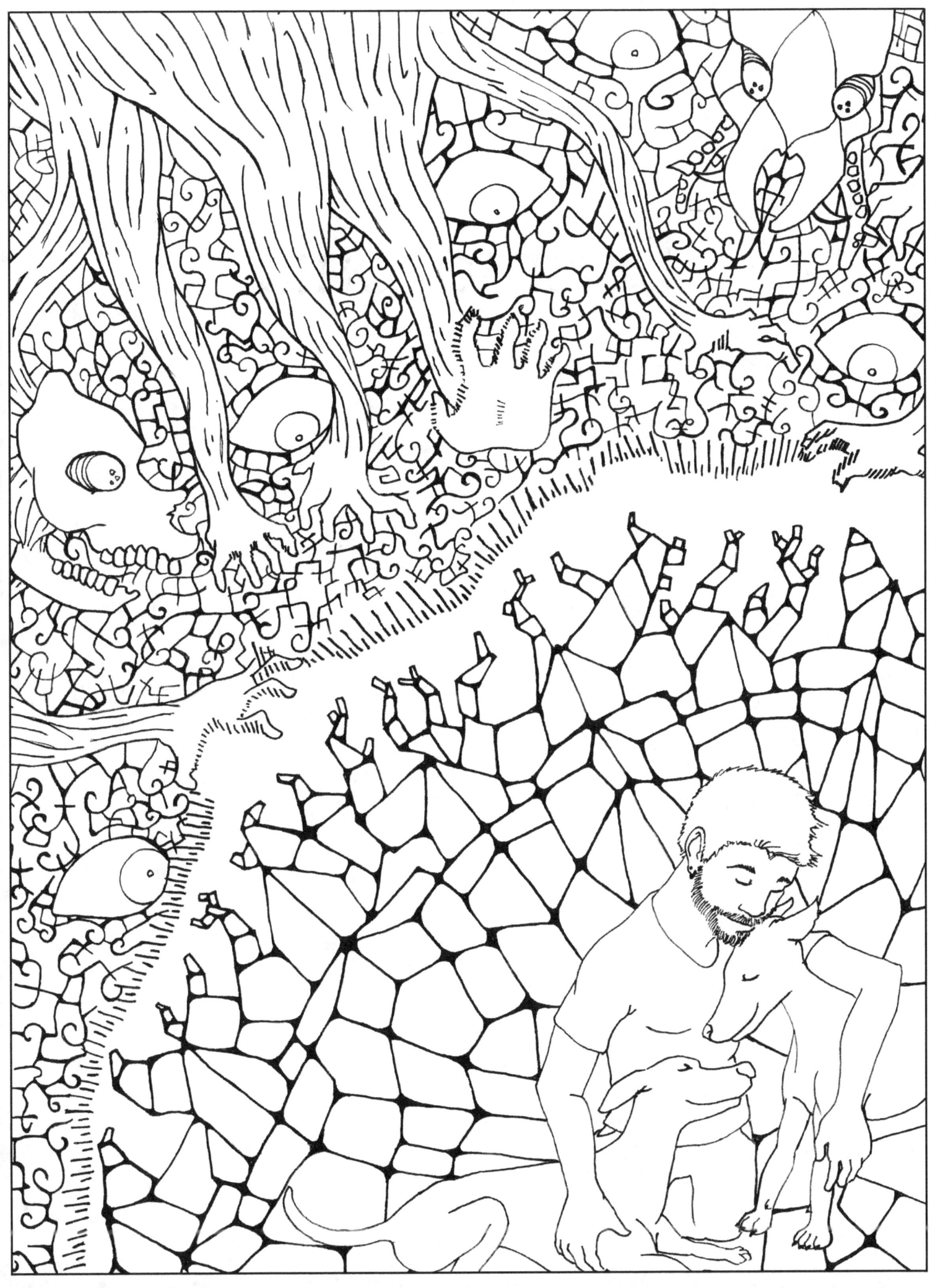

Dysmorphia

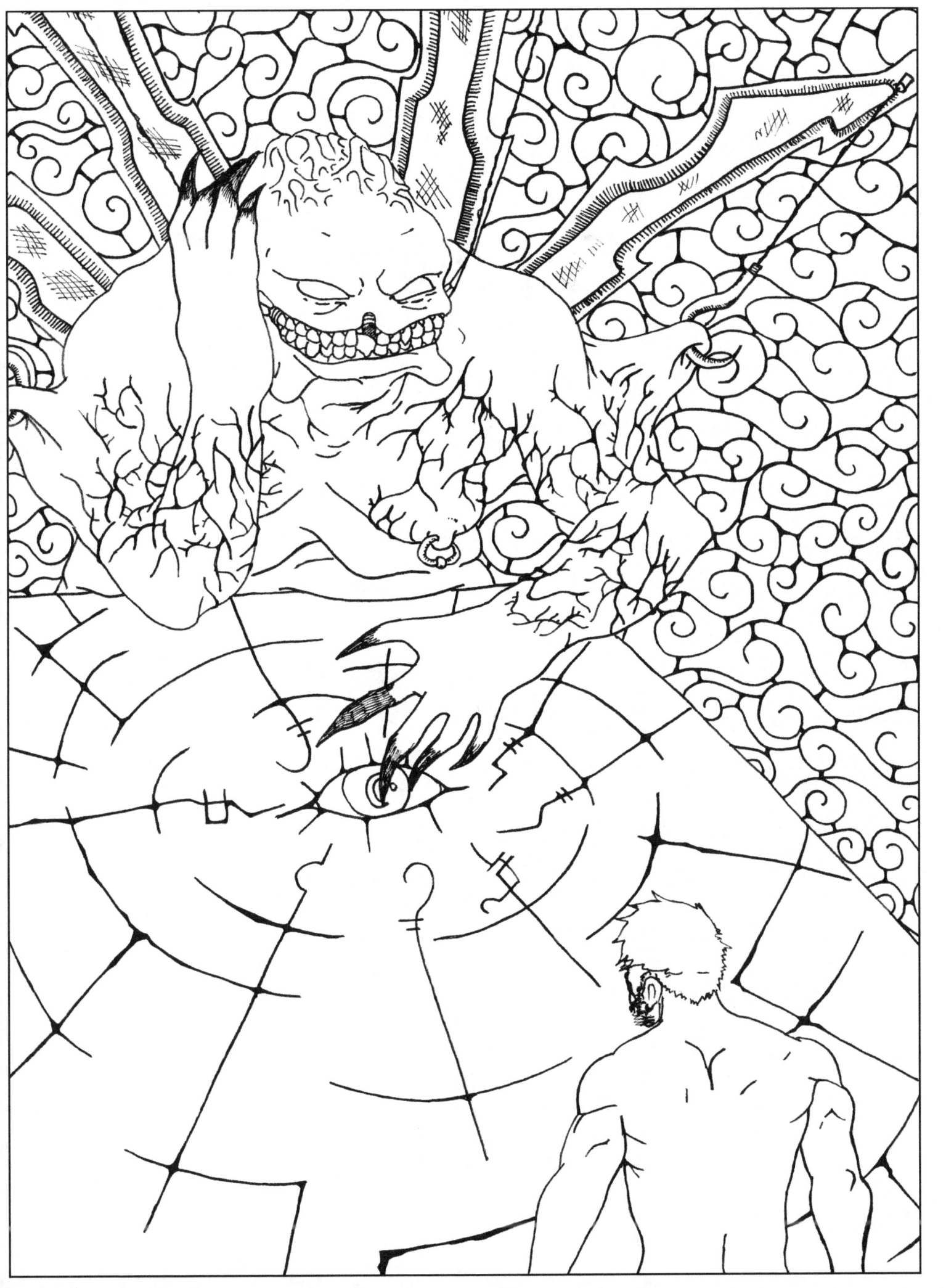

Exposure

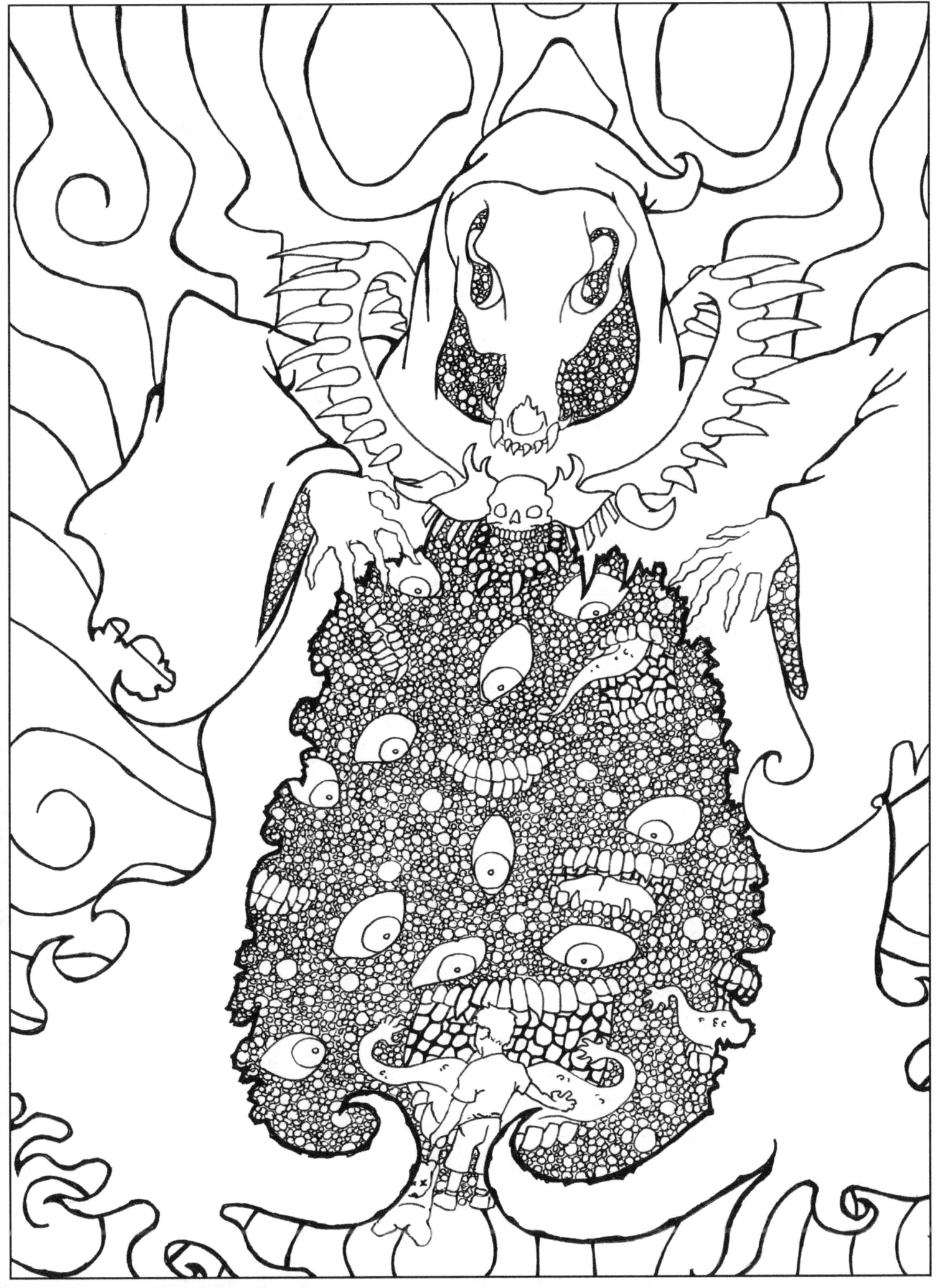

Unconditional Love

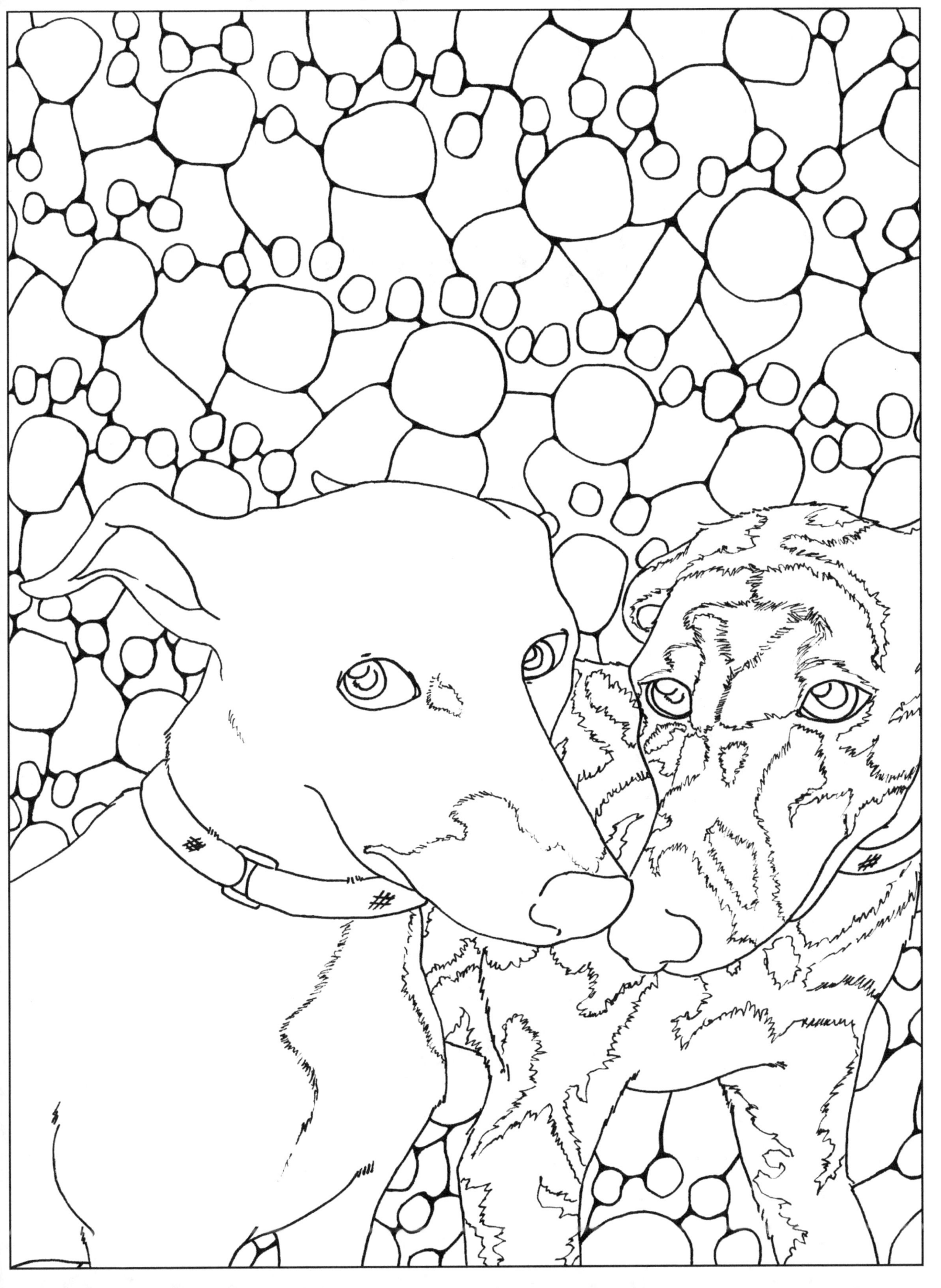

Net Profit

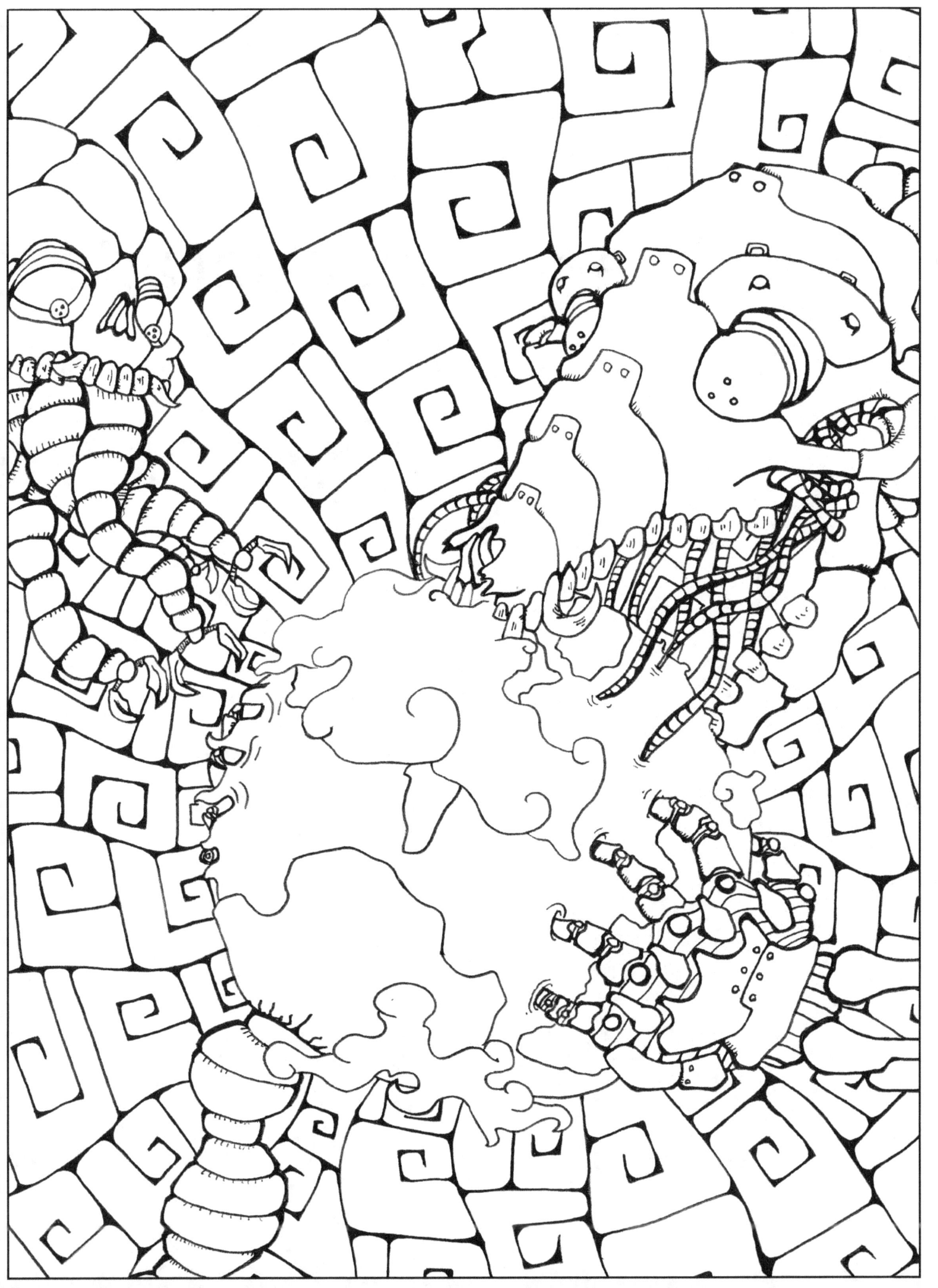

The Grand Masquerade

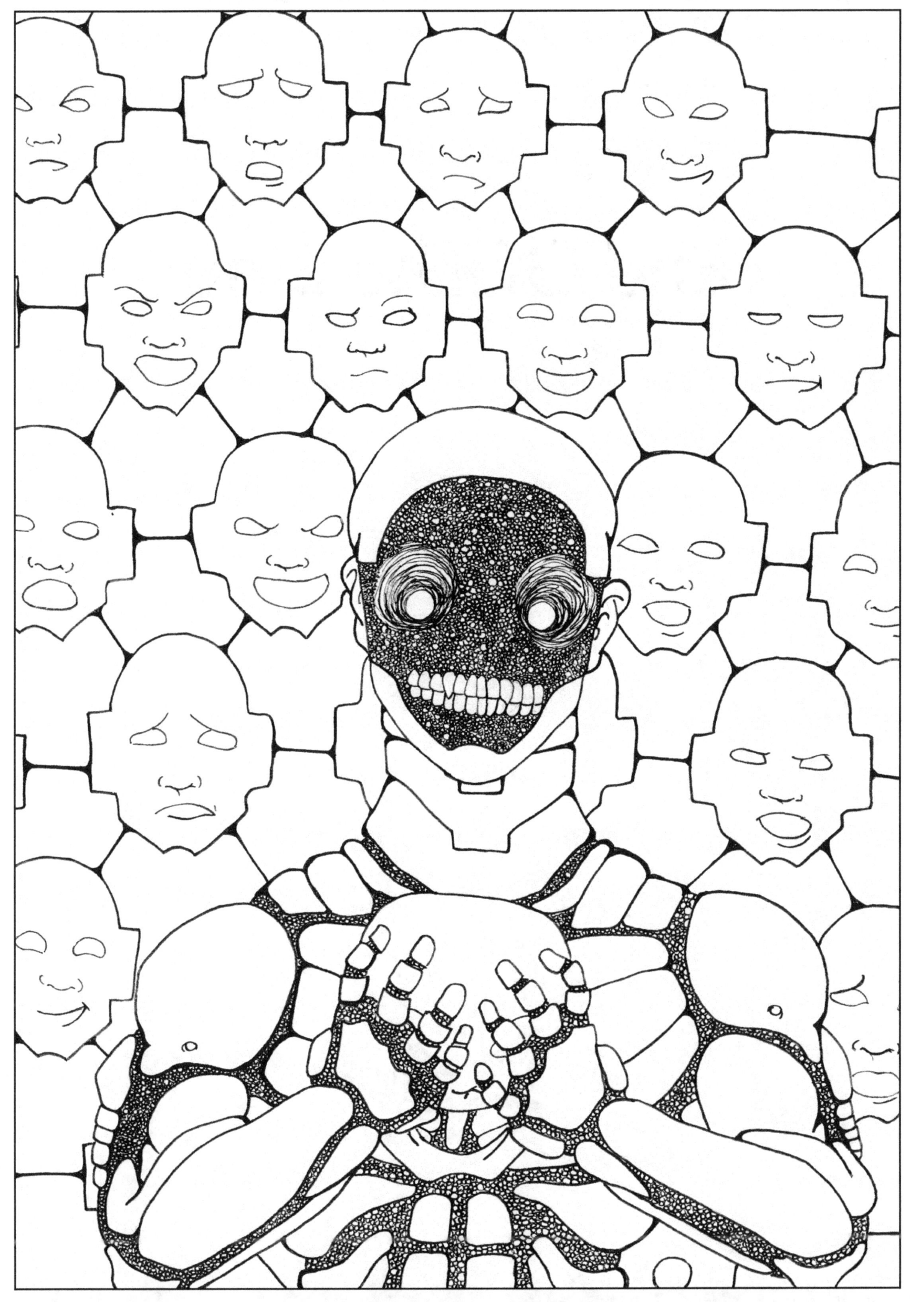

End Of The Line

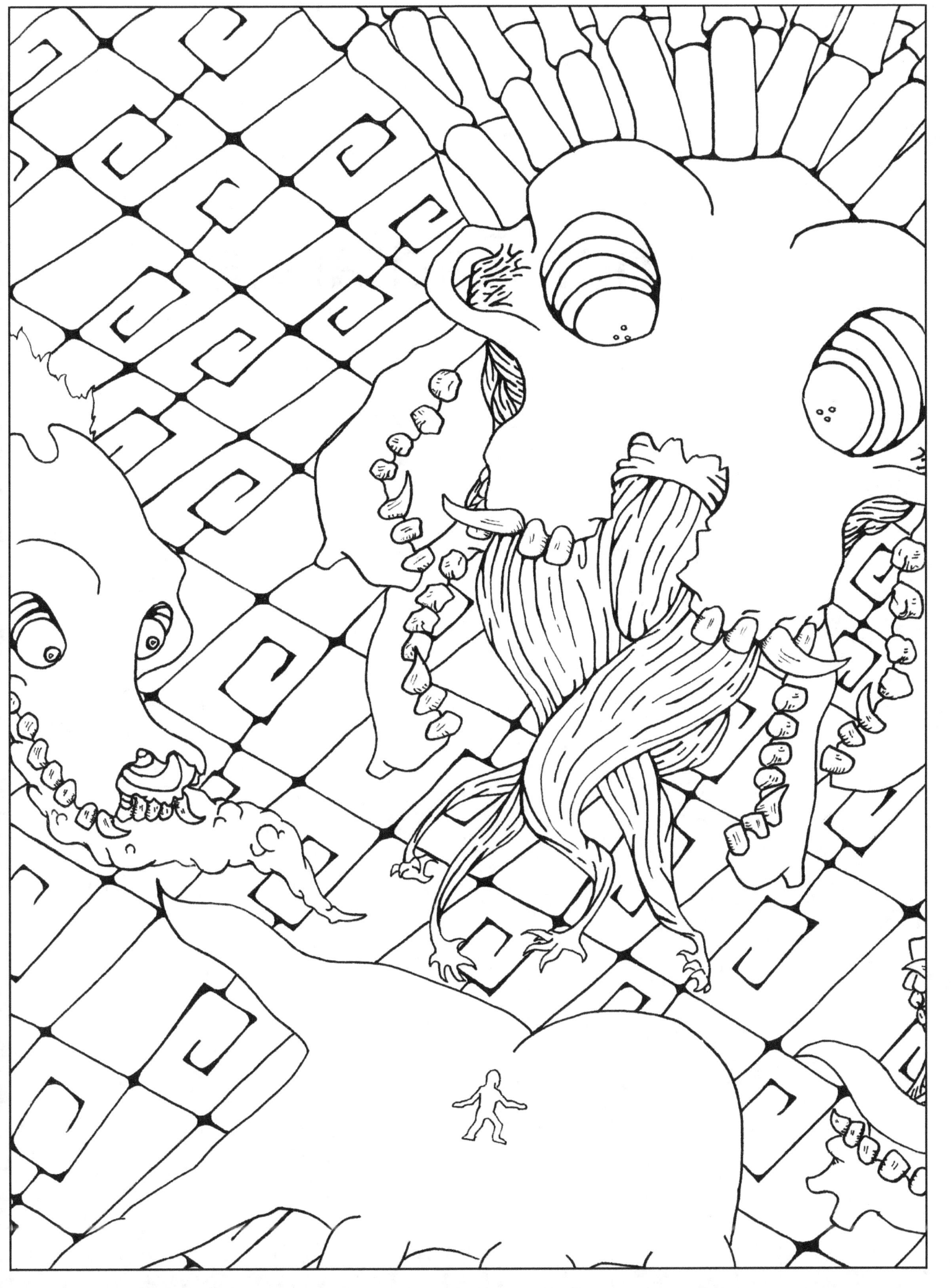

Inner Radiance

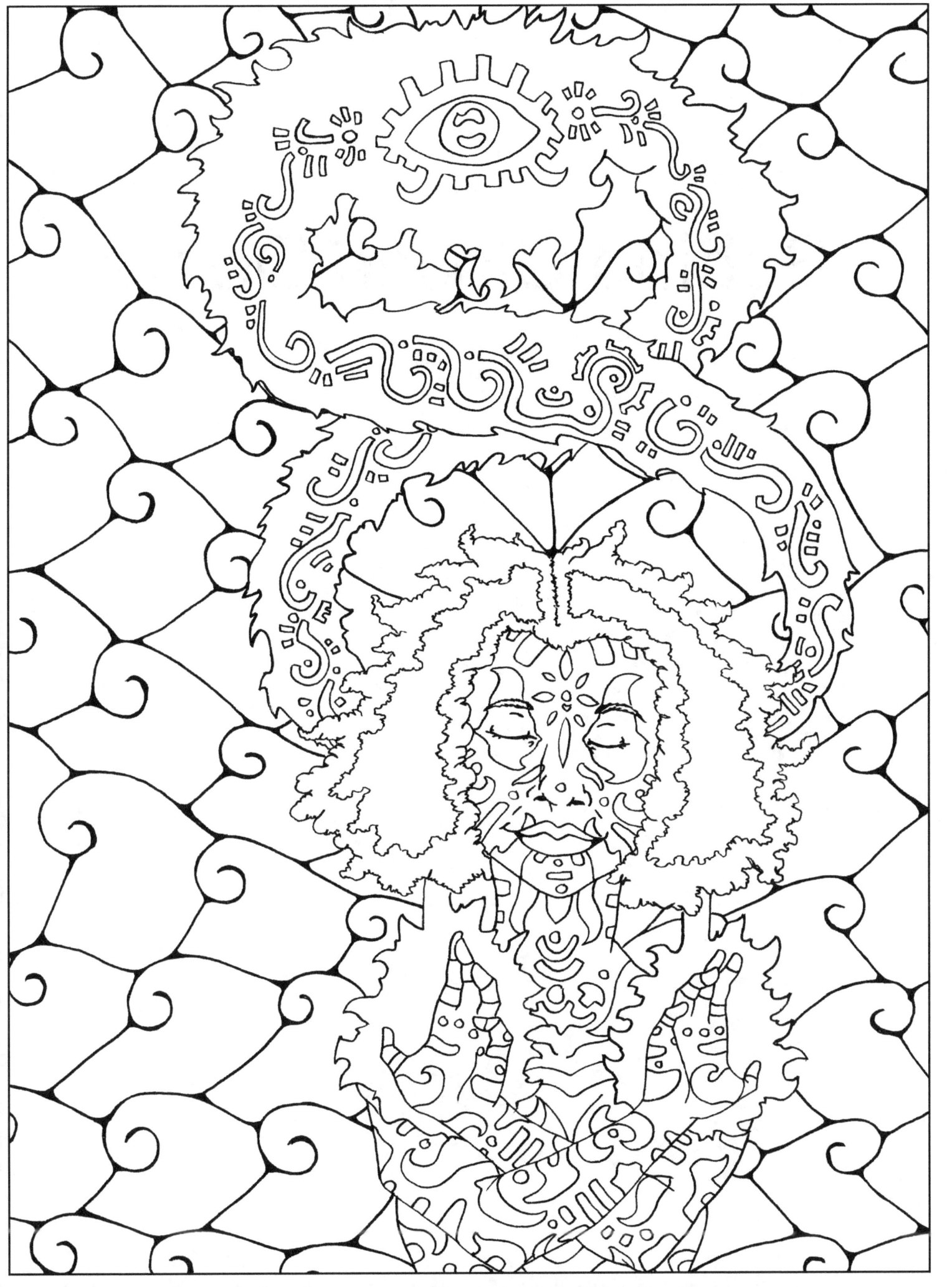

Behind Closed Doors

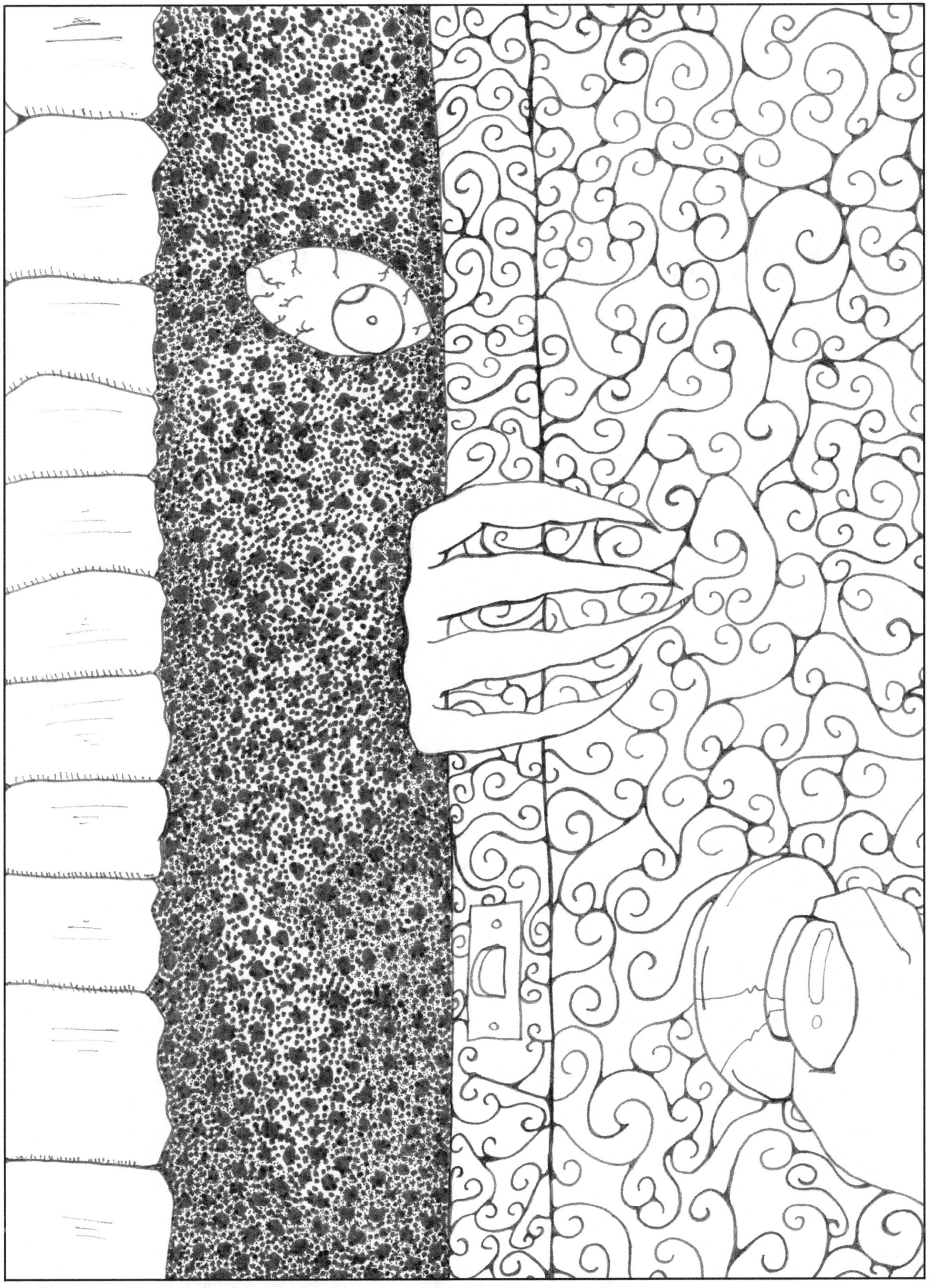

Your One True Friend

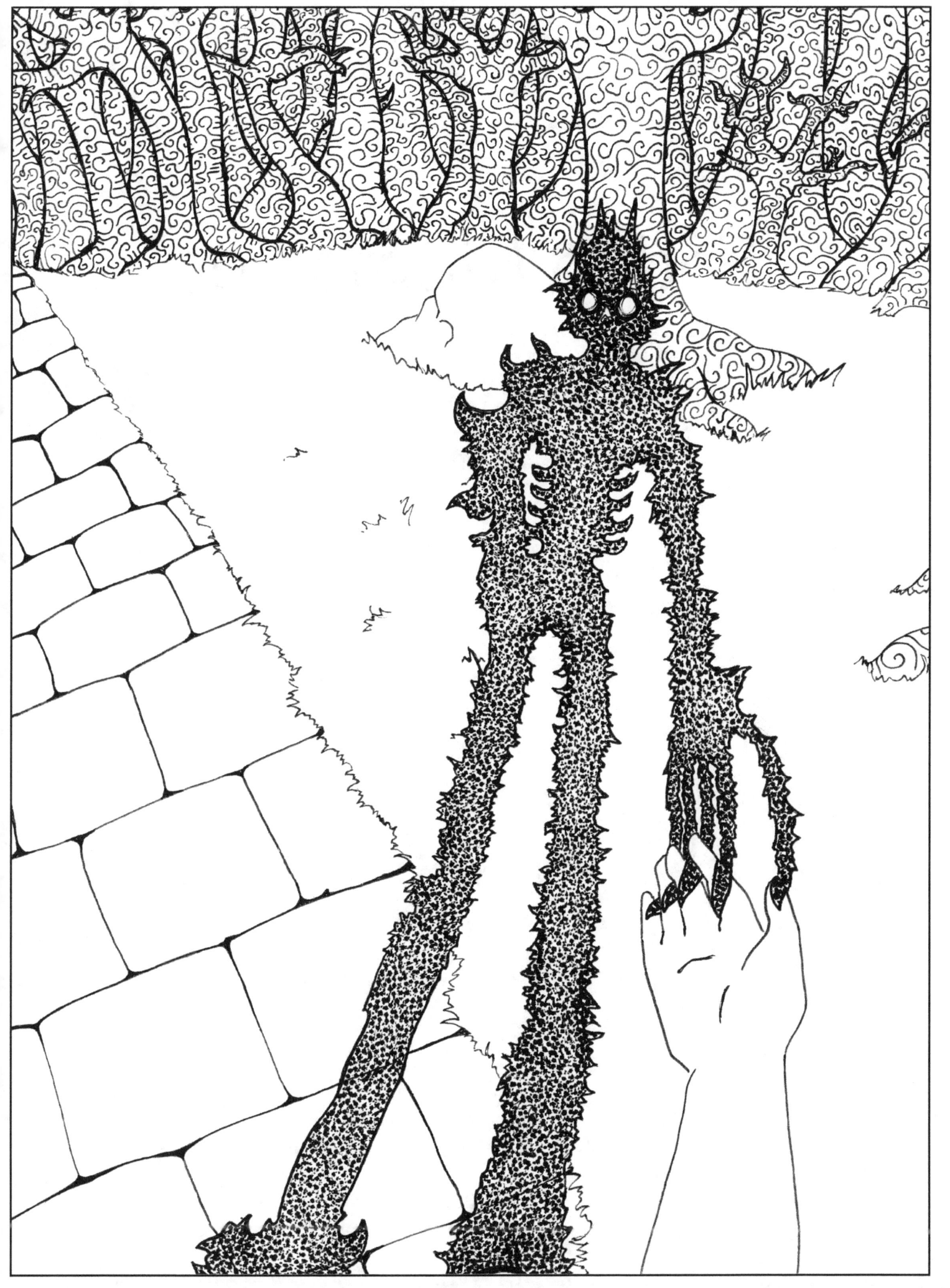

Faded Memories

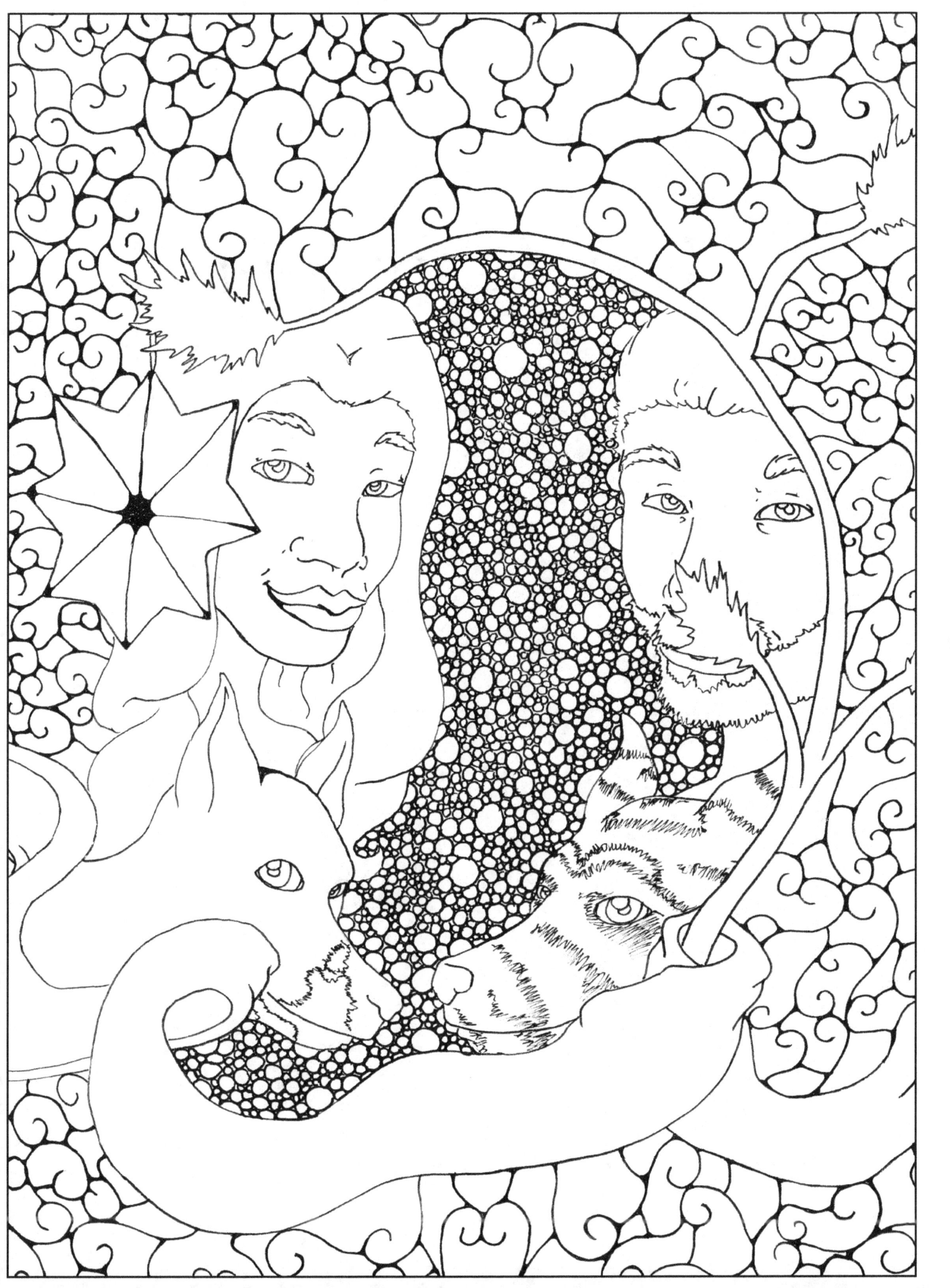

The Puppeteer

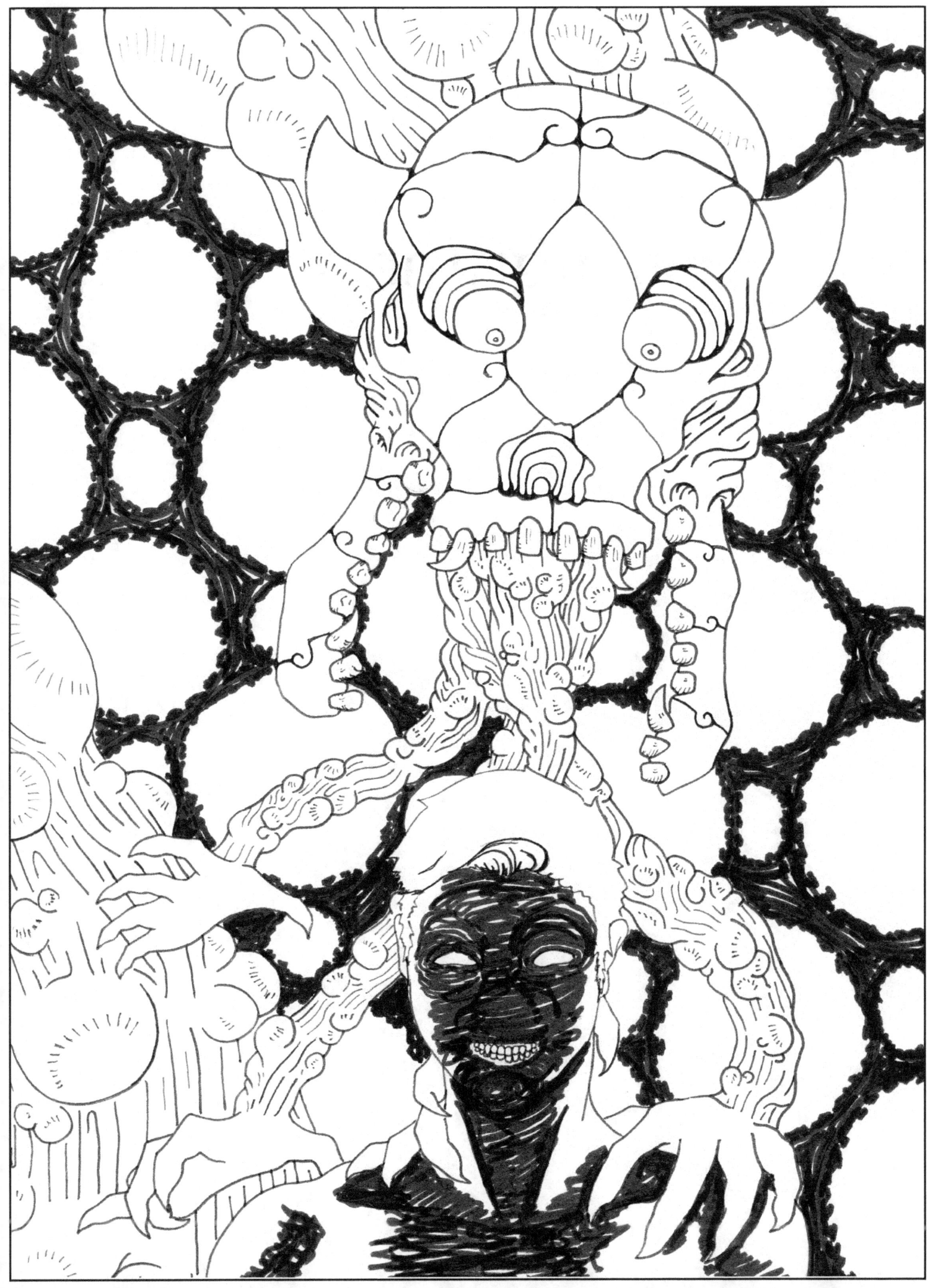

Alignment

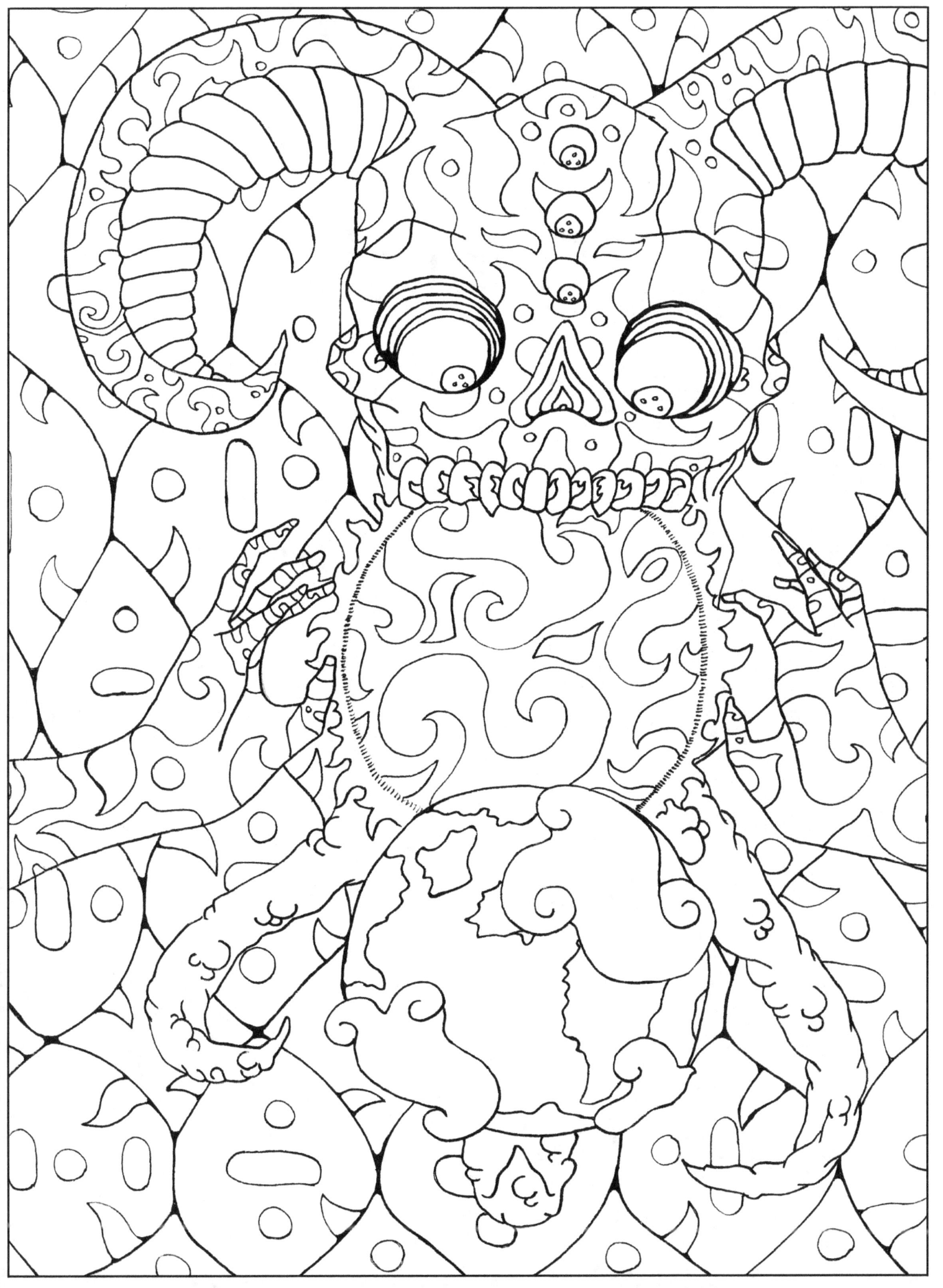

Gemini

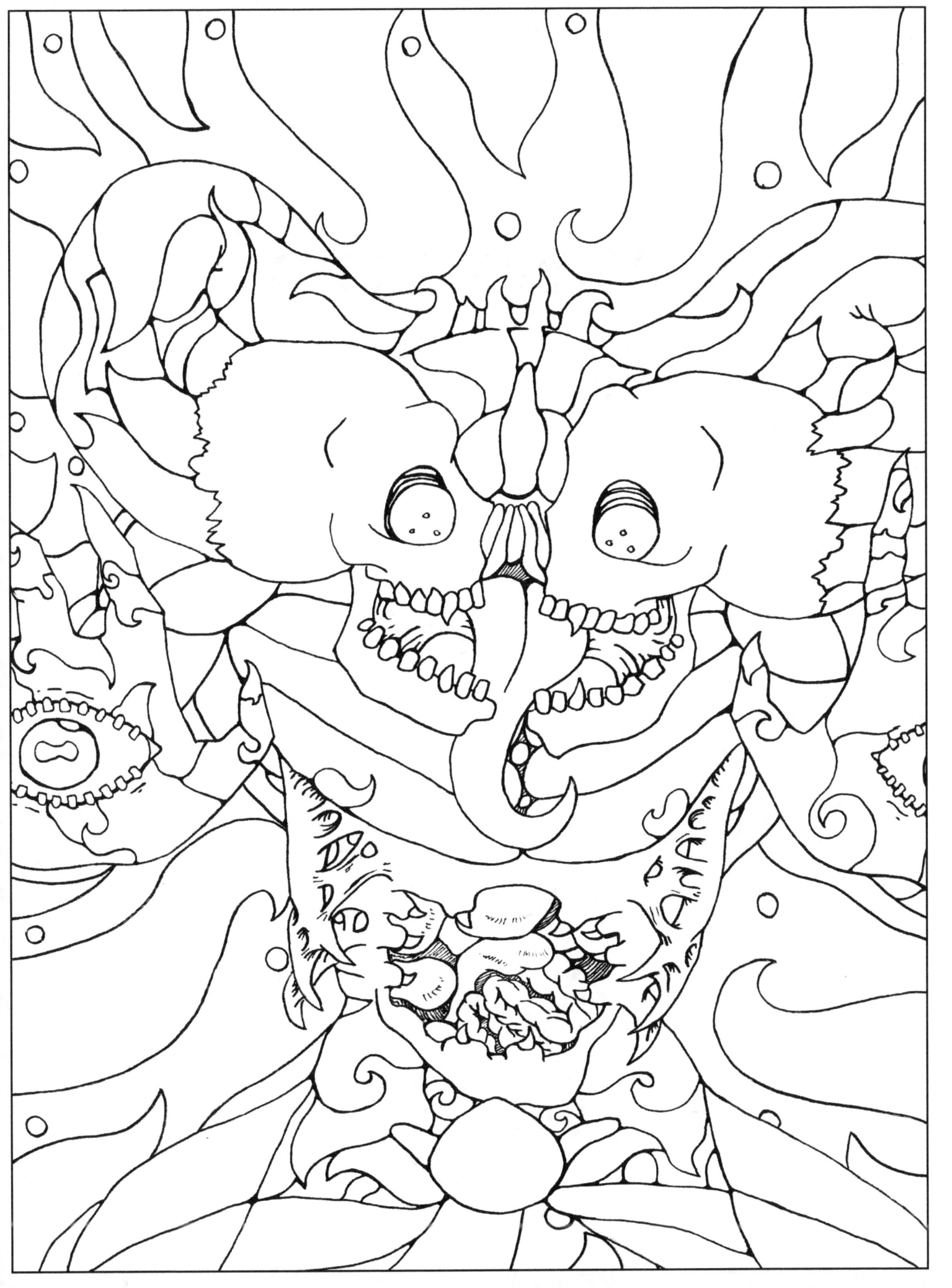

Masochism

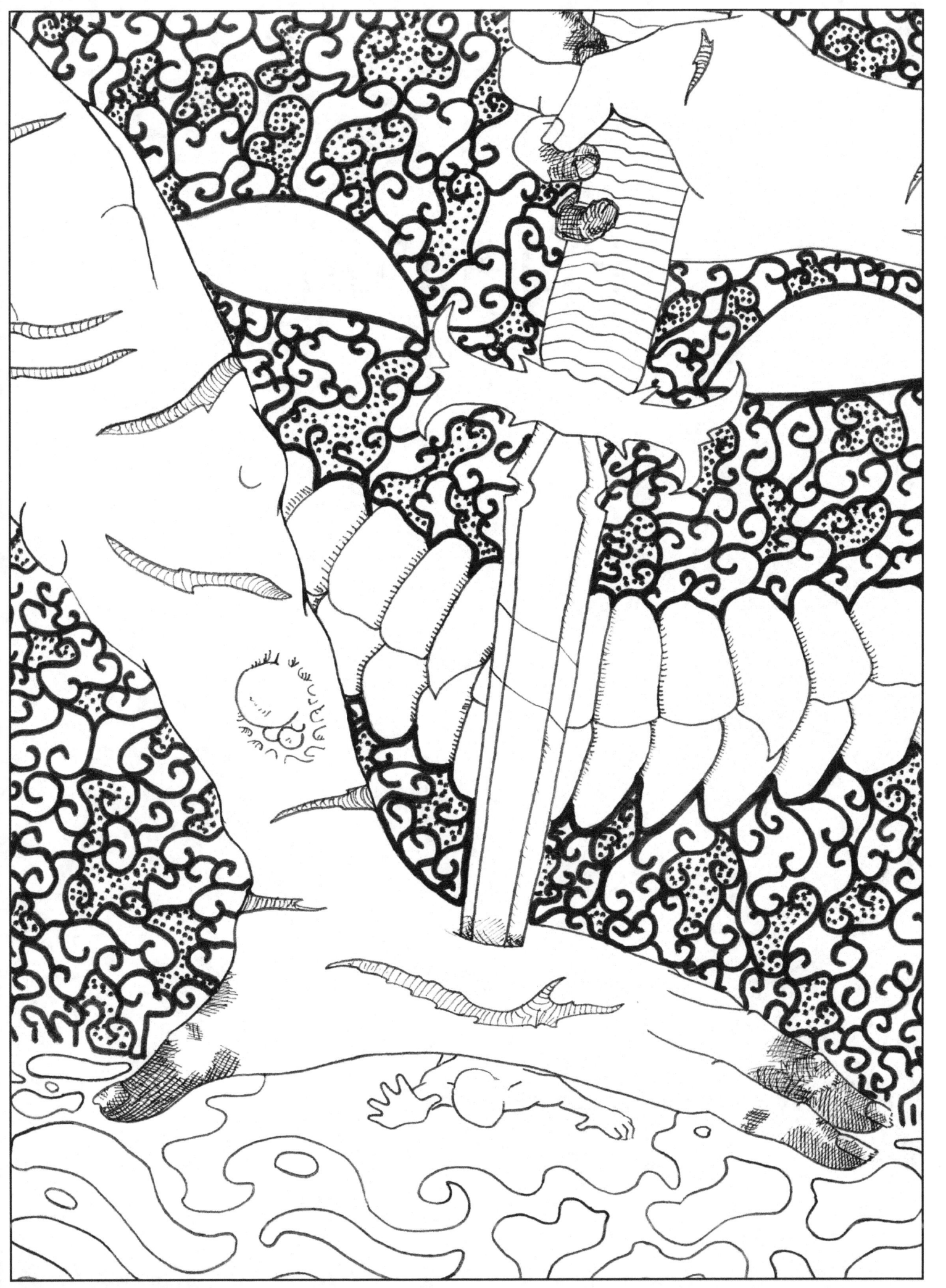

Rejection

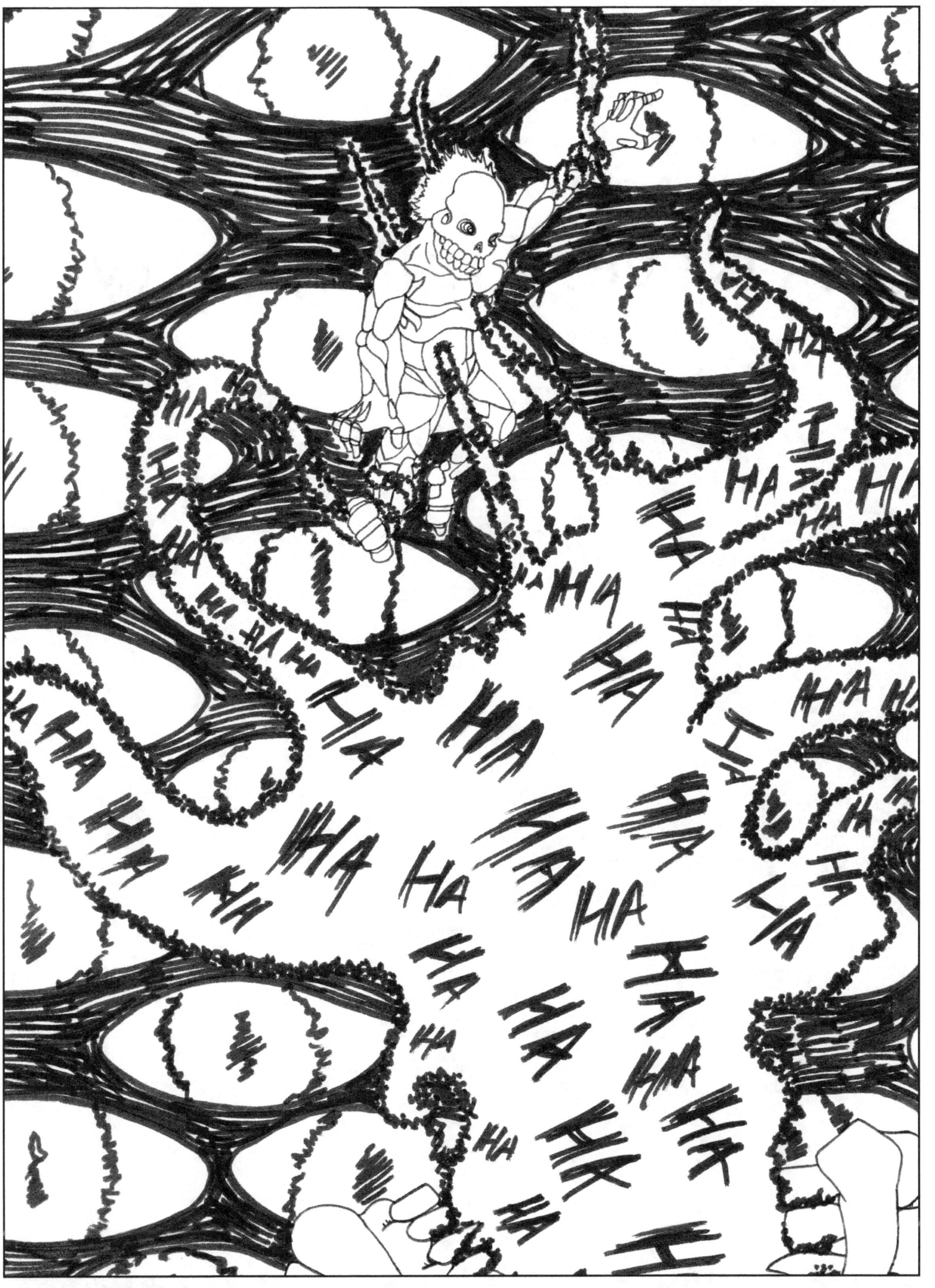

A Never Ending Party

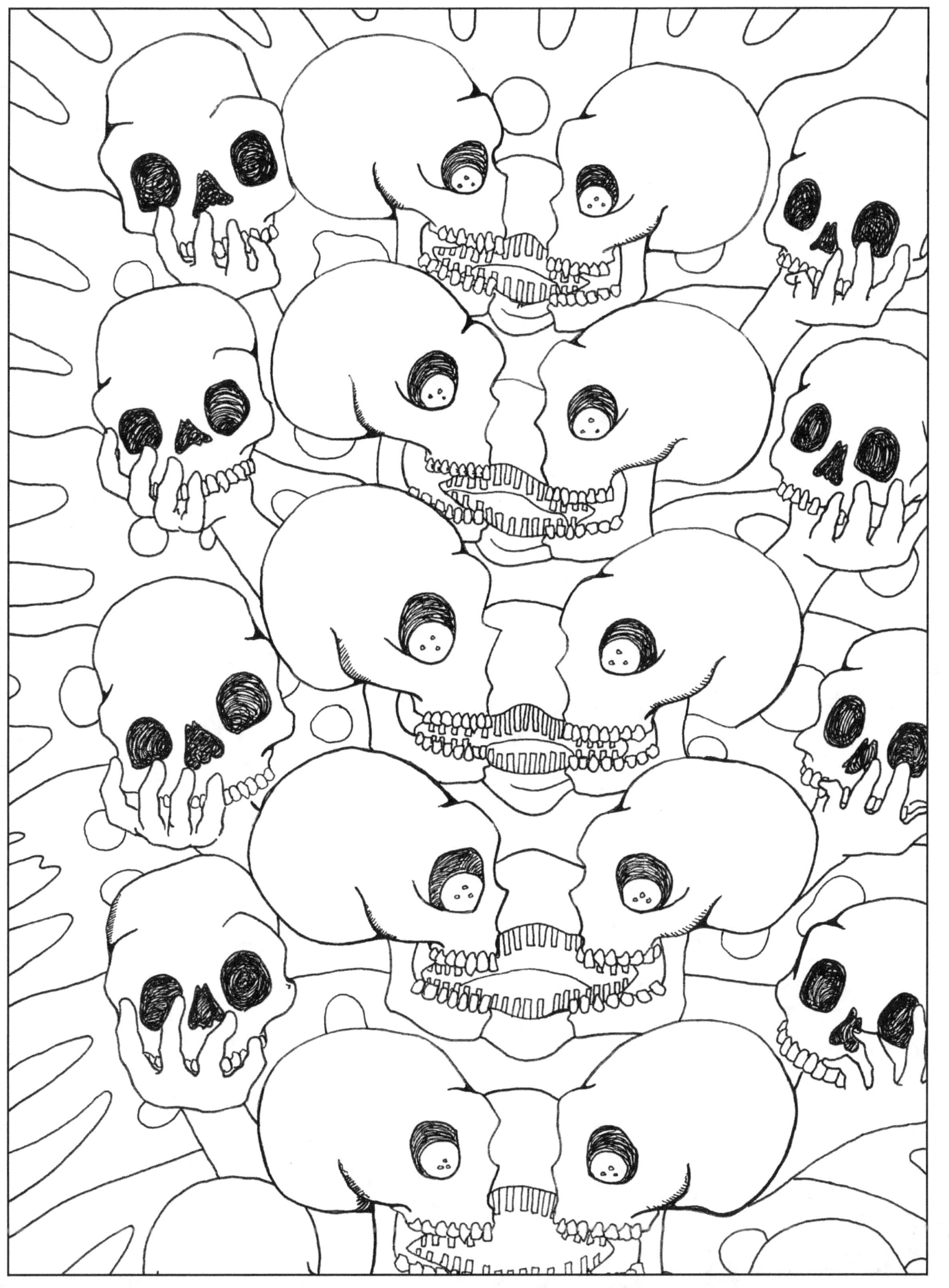

www.ingramcontent.com/pod-product-compliance
Lightning Source LLC
Chambersburg PA
CBHW080829170526
45158CB00009B/2542